ANATOMY

THE COLORING BOOK

CERNUNNOS

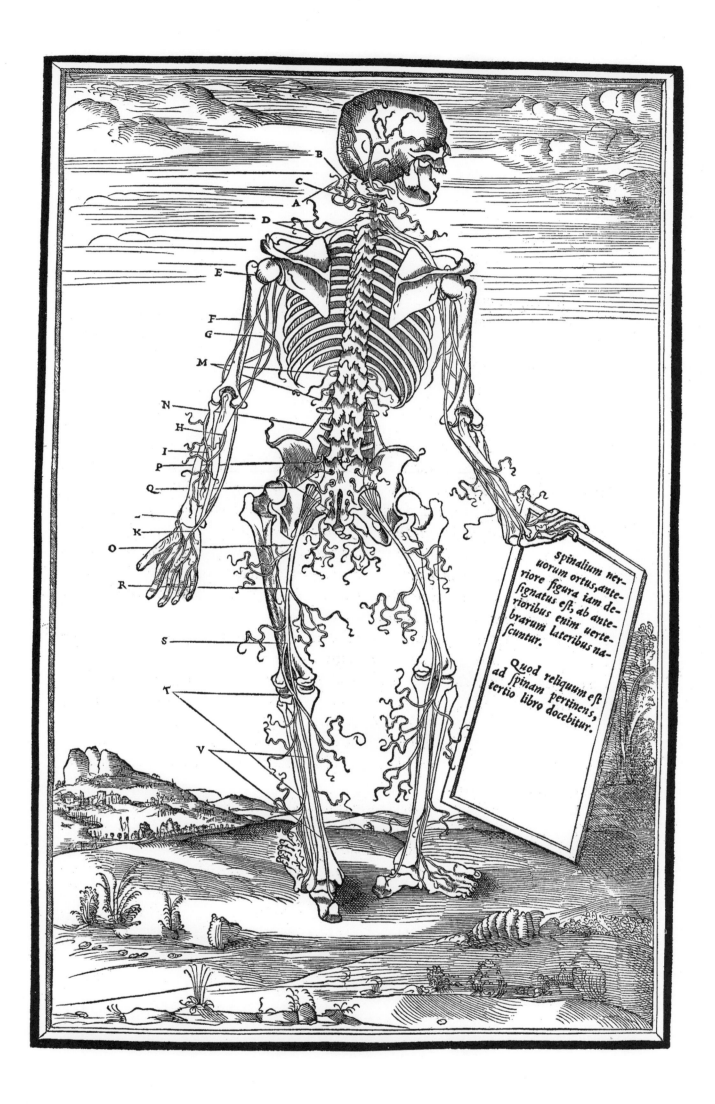

Human skeleton showing posterior nerves
Étienne de La Rivière, *De dissectione partium corporis humani.* 16th Century.

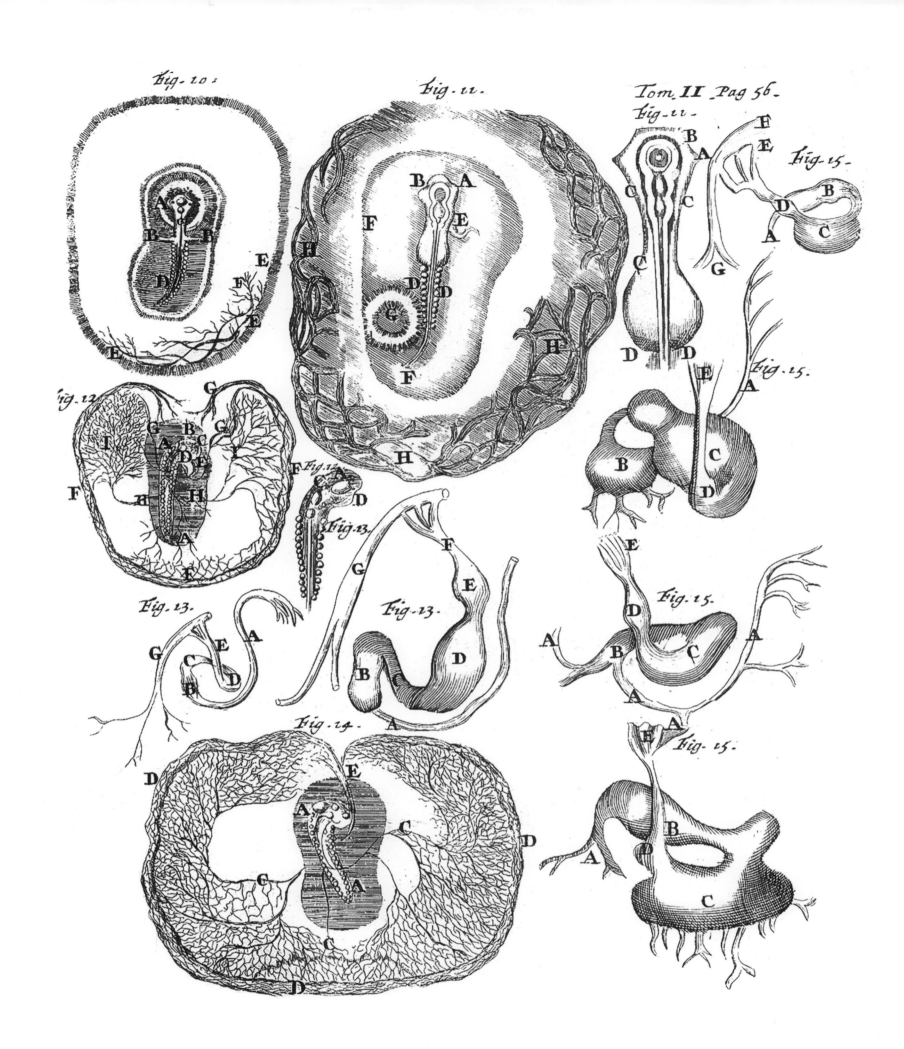

De formatione pulli in ovo. Embriology of the chick
Marcello Malpighi, *Opera omnia, figuris elegantissimis in aes incisis illustrata*. 1687.

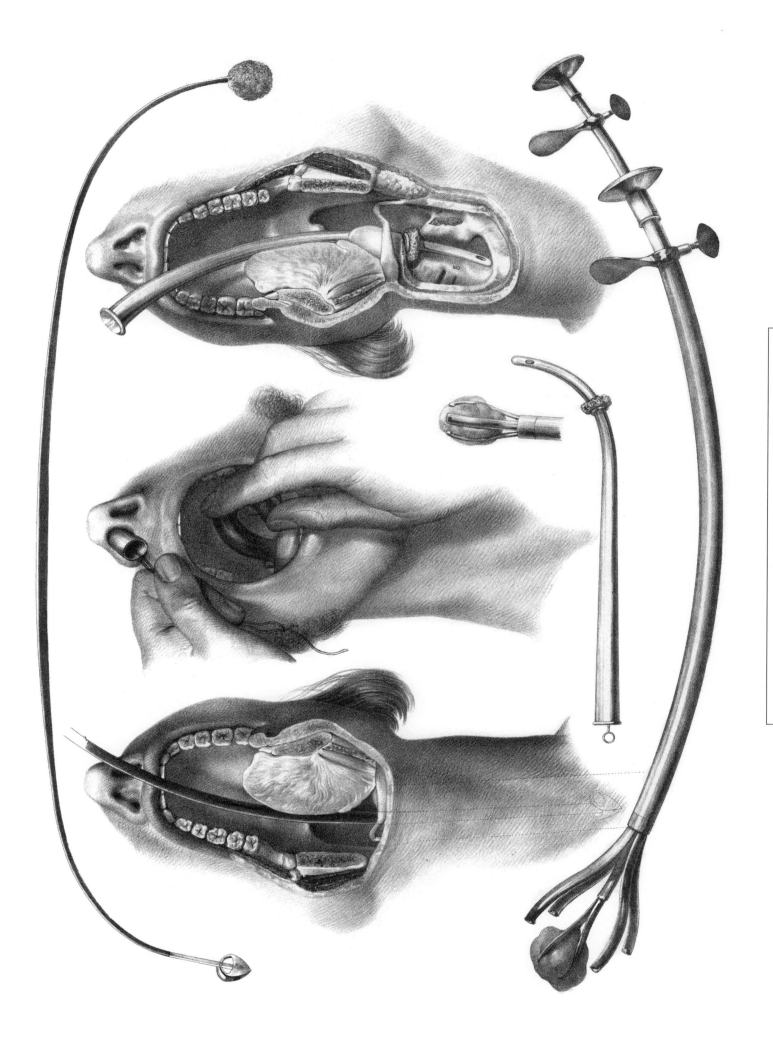

An instrument used to insert an artificial airway into the trachea and to remove foreign bodies

Nicolas-Henri Jacob, *Traité complet de l'anatomie de l'homme comprenant la médecine opératoire.* 1840.

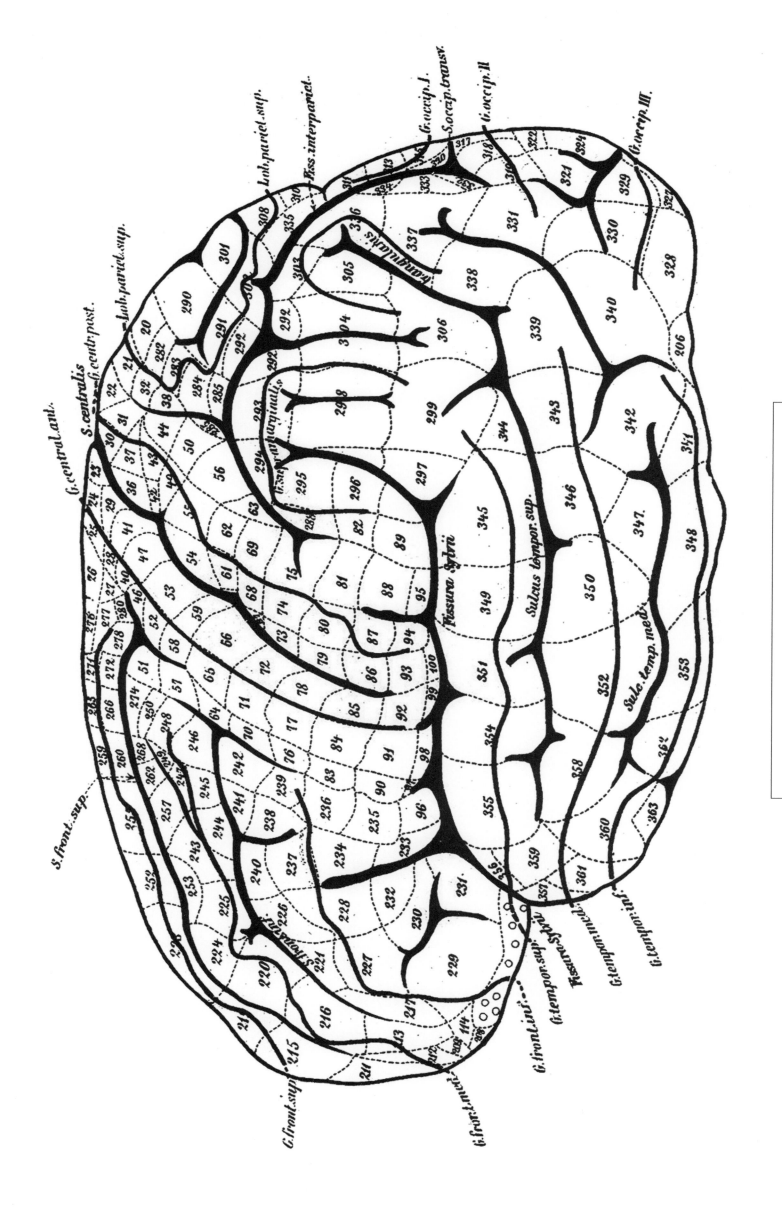

Cerebra localisation

Exner Siegmund, *Untersuchungen über die Localisation der Functionen in der Grosshirnrinde des Menschen.* 1881.

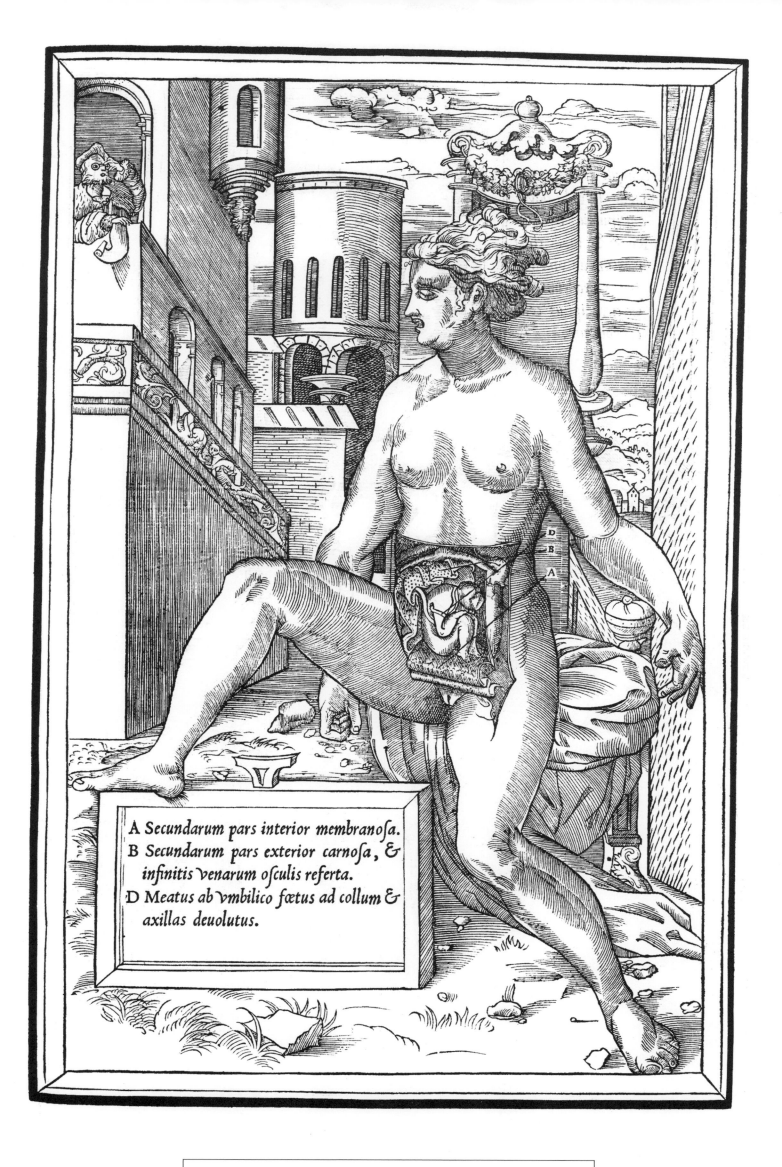

A Secundarum pars interior membranoſa.
B Secundarum pars exterior carnoſa, &
 infinitis venarum oſculis referta.
D Meatus ab vmbilico fœtus ad collum &
 axillas deuolutus.

Illustration of a pregnant woman showing the foetus
Charles Estienne, *De dissectione partium corporis humani.* 1545.

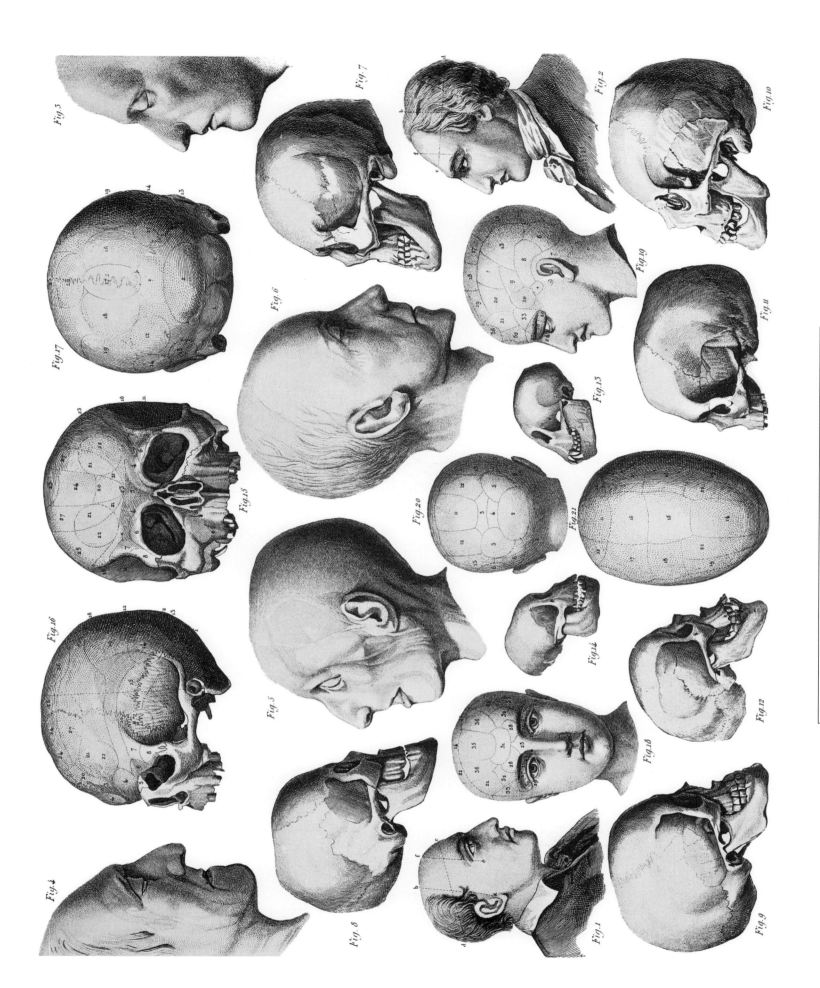

Phrenology Chart

Unknown Artist. *Brockhaus and Efron Encyclopedic Dictionary*. 1890.

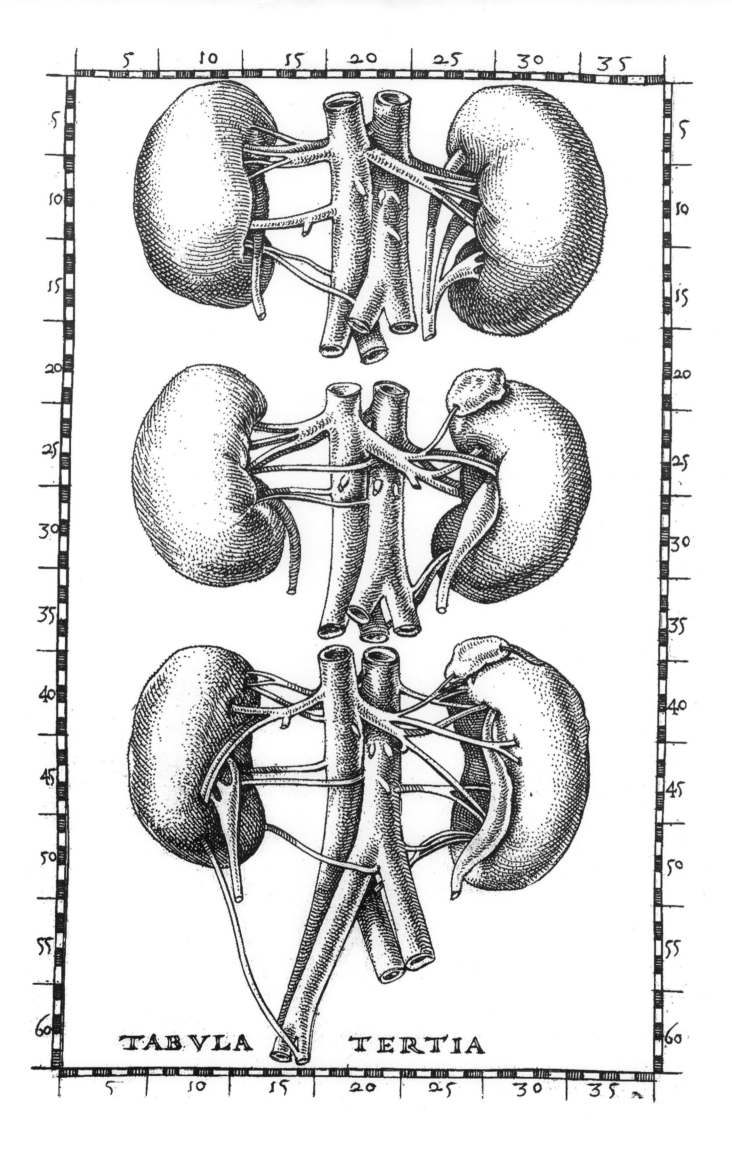

TABVLA TERTIA

Tabula tertia
Eustachius Bartolomaeus, *Tabulae anatomicae*. 1728.

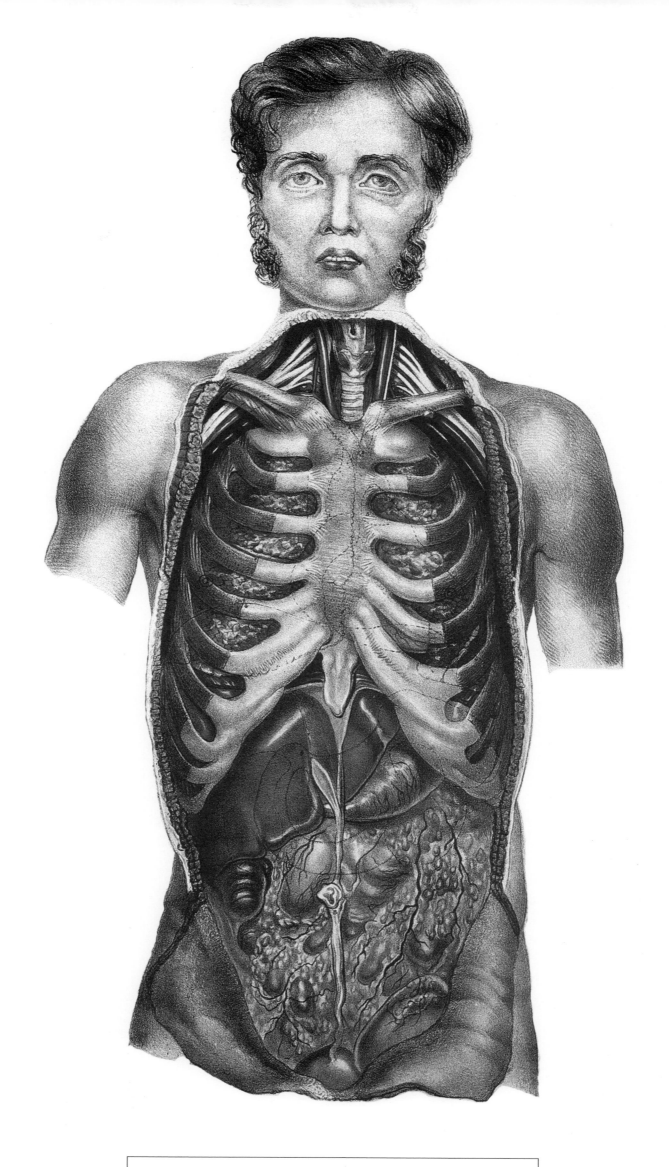

Anatomy
By Sibson after William T. Fairland, *Litograph published by John Churchill.* 1869.

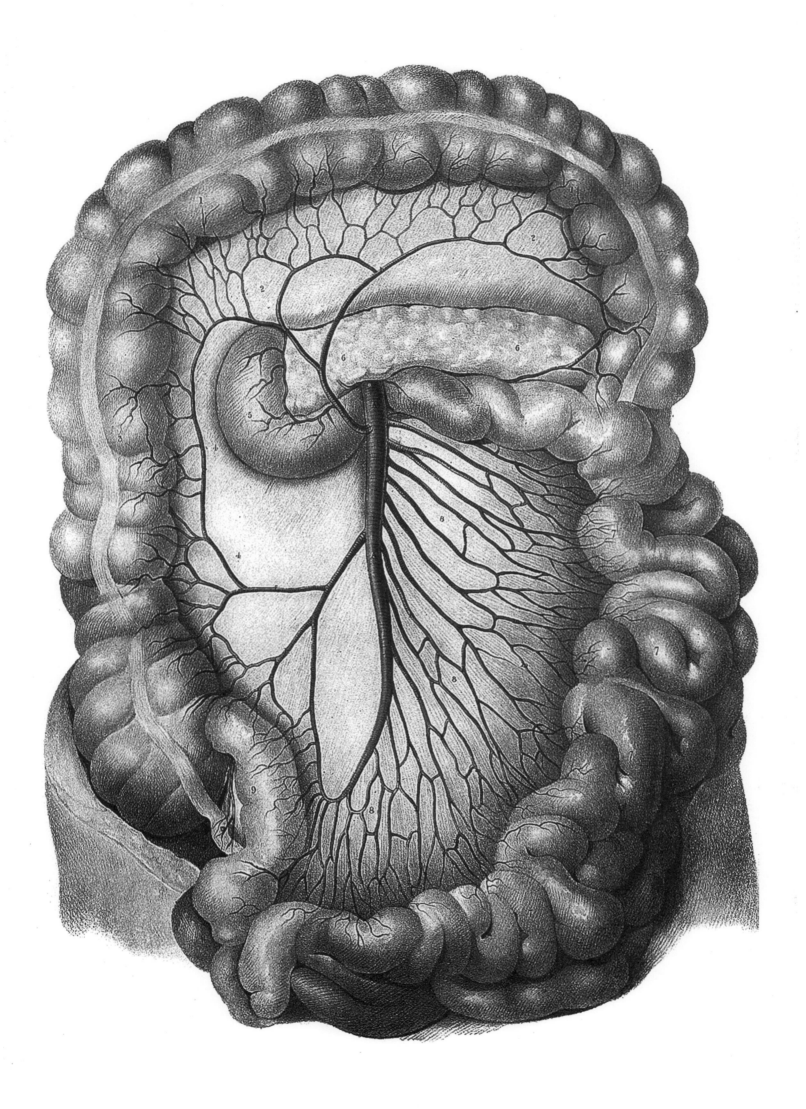

**Annotated engraving of the superior mesenteric artery
and the small and large intestines**
Quain & Wilson, *The vessels of the human body.* 1837.

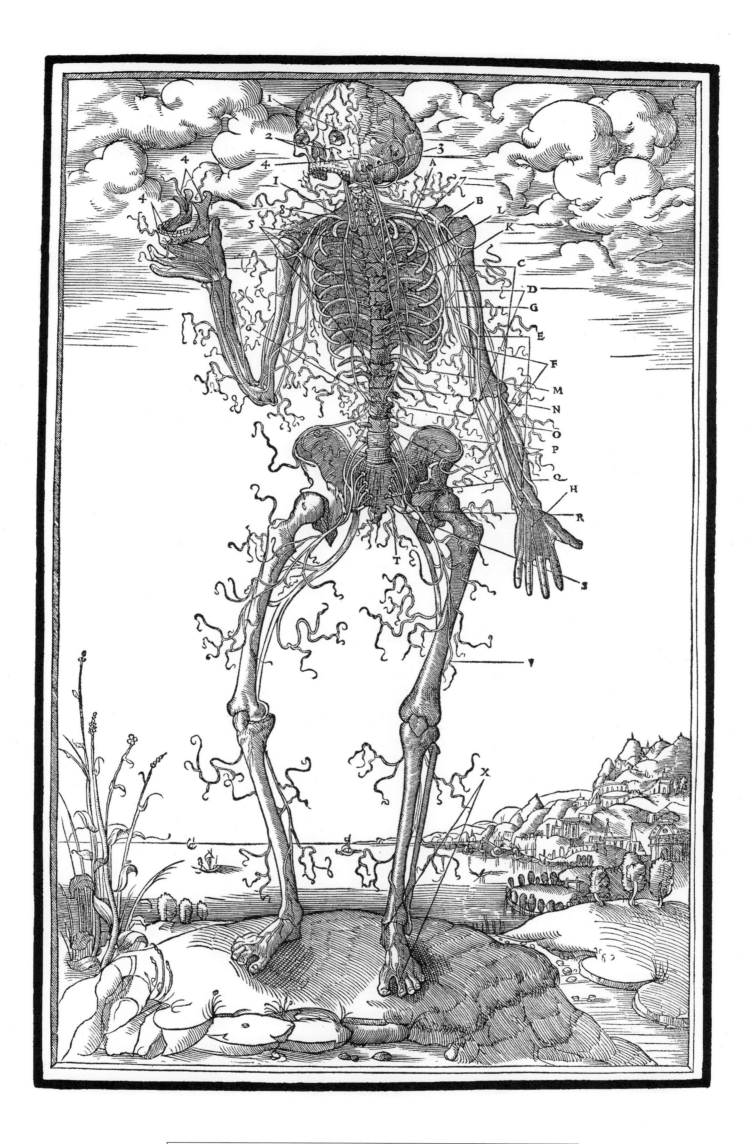

Human skeleton showing anterior nerves
Étienne de La Rivière, *De dissectione partium corporis humani*. 16th Century.

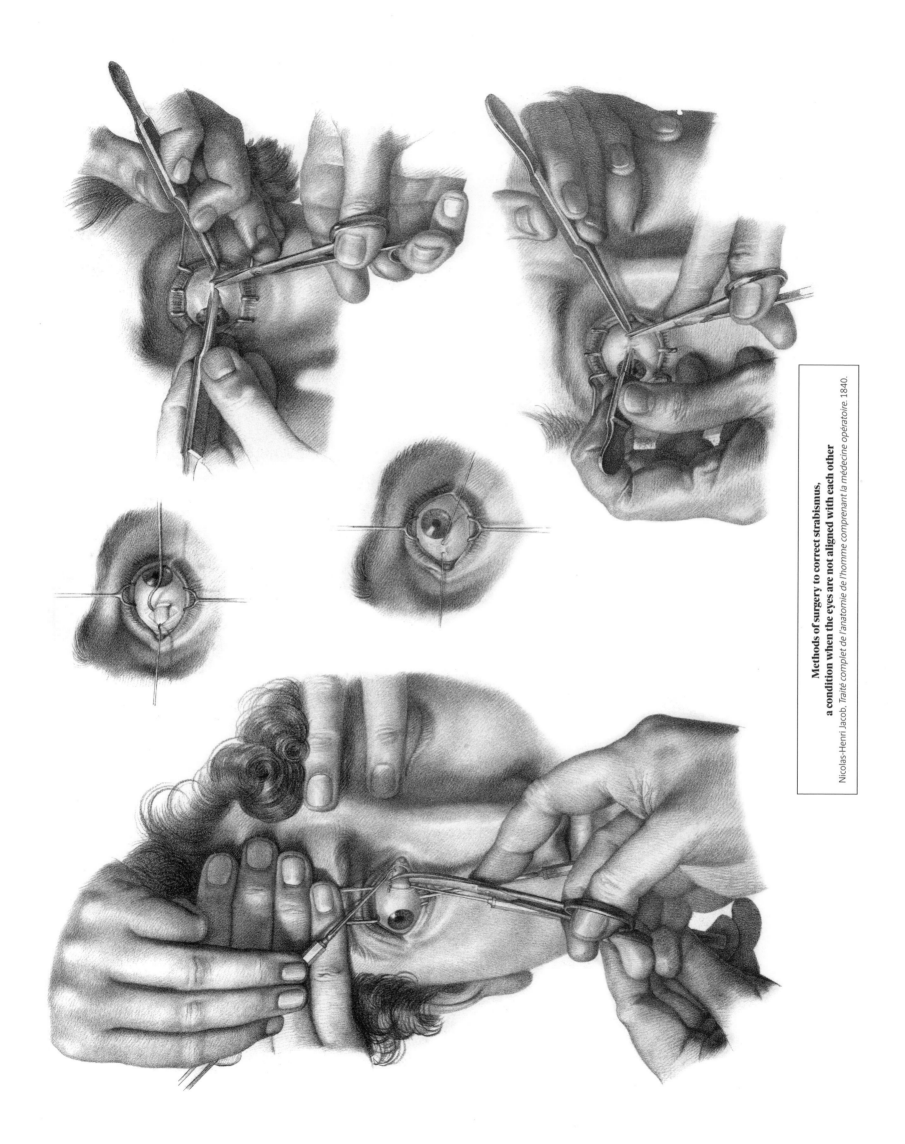

**Methods of surgery to correct strabismus,
a condition when the eyes are not aligned with each other**

Nicolas-Henri Jacob, *Traité complet de l'anatomie de l'homme comprenant la médecine opératoire. 1840.*

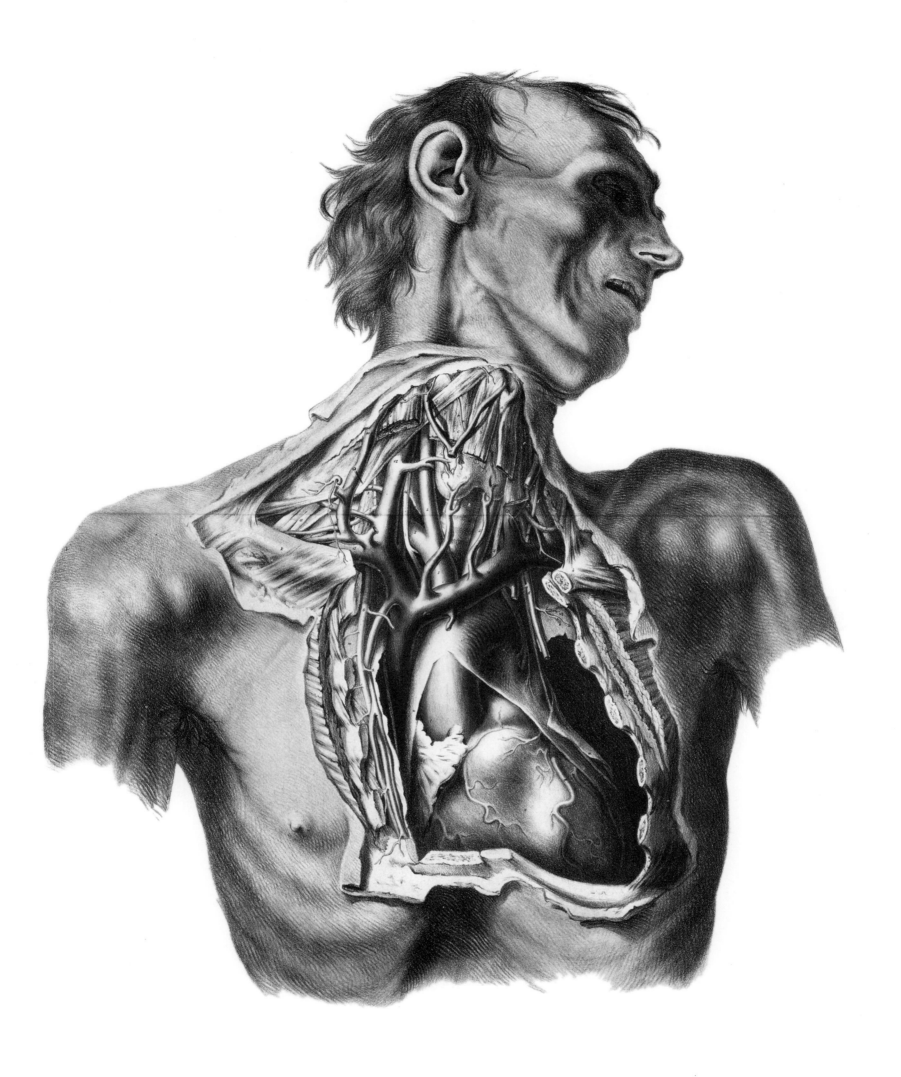

The large arteries of thorax and neck
Joseph Maclise, *The anatomy of the arteries of the human body and its applications to pathology and operative surgery.* 1844.

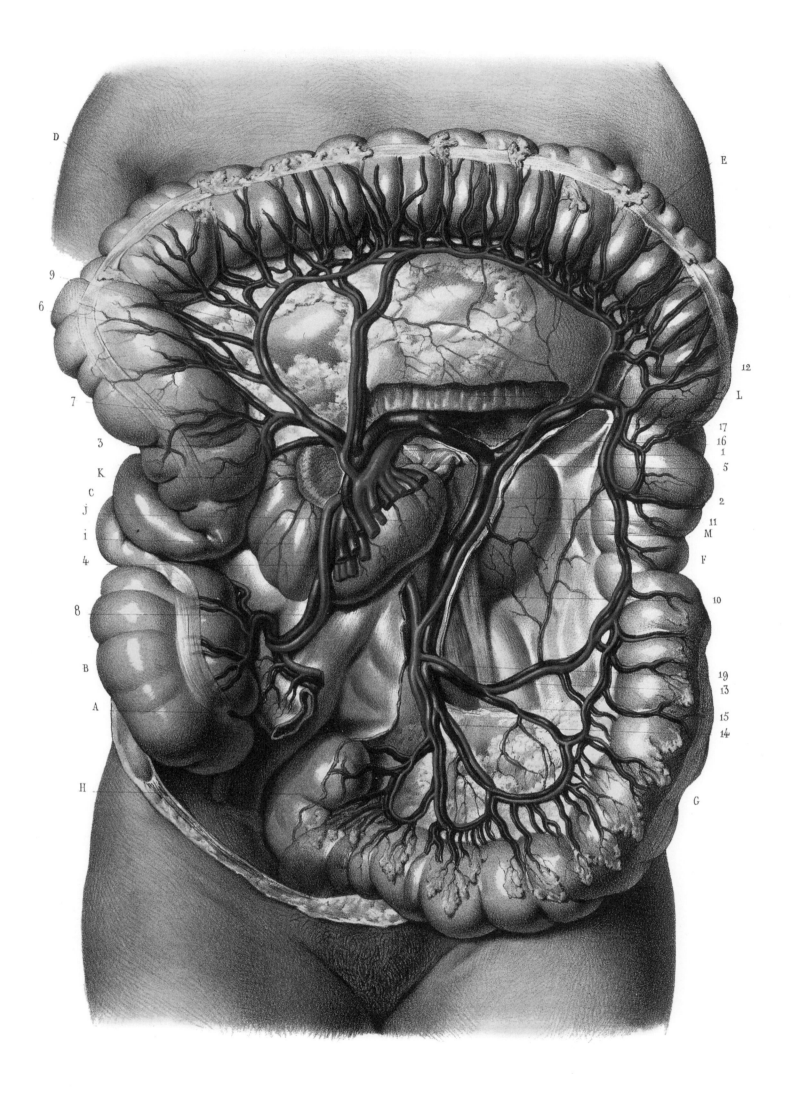

Veins and arteries
Emile Beau, *Atlas d'anatomie descriptive du corps humain*. 1866.

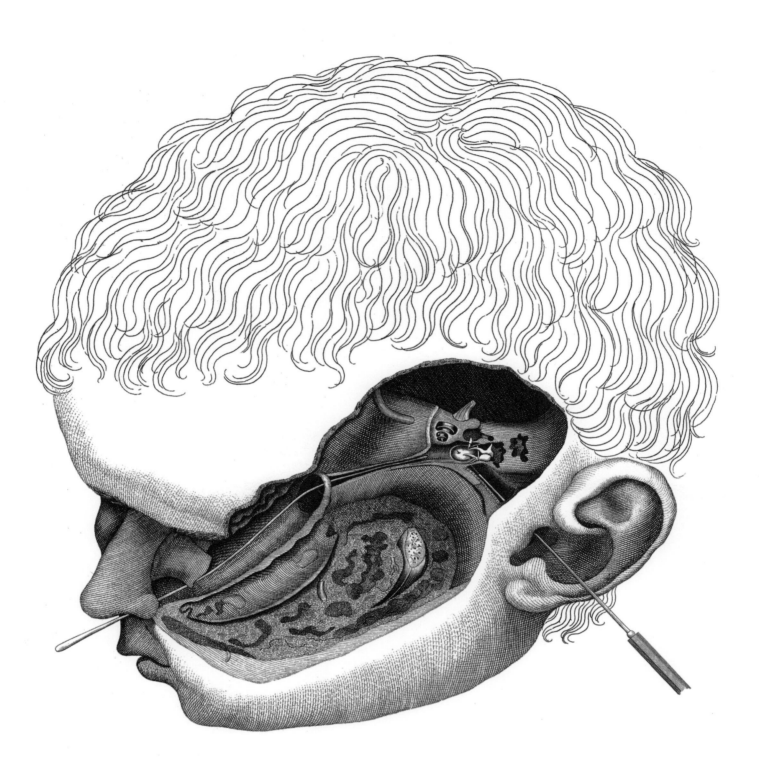

Engraving showing anatomy of the ear
Thomas Buchanan, *An engraved representation of the anatomy of the human ear.* 1823.

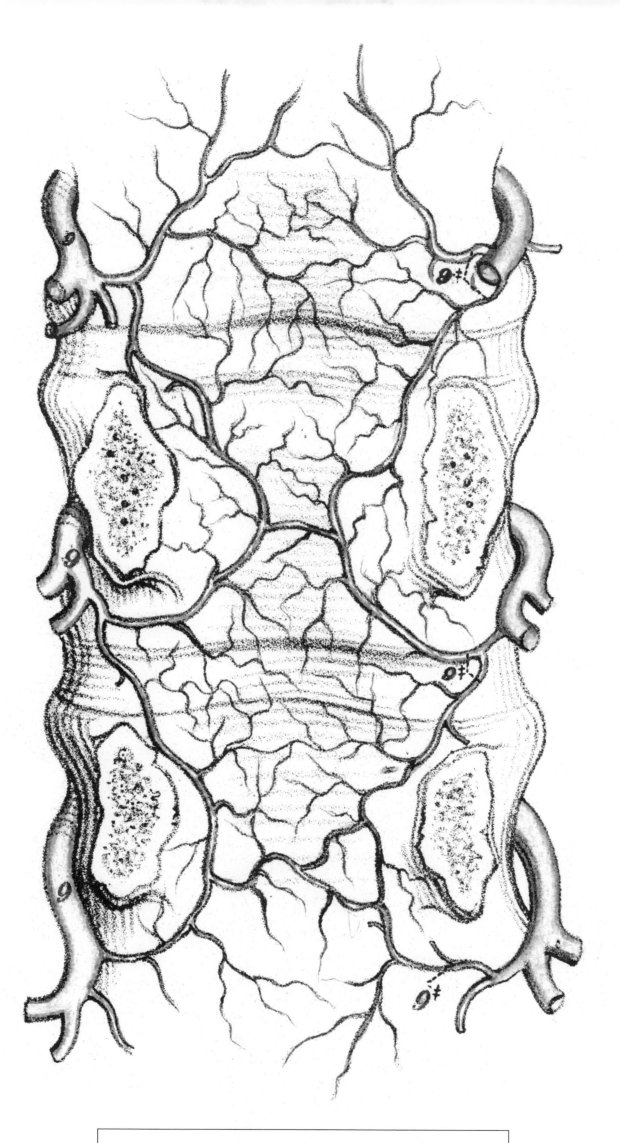

**Illustration showing arteries supplying spinal cord, being branches
of the arteries which enter the spinal canal at various points**
Joseph Maclise, *The anatomy of the arteries of the human body and its applications
to pathology and operative surgery.* 1844.

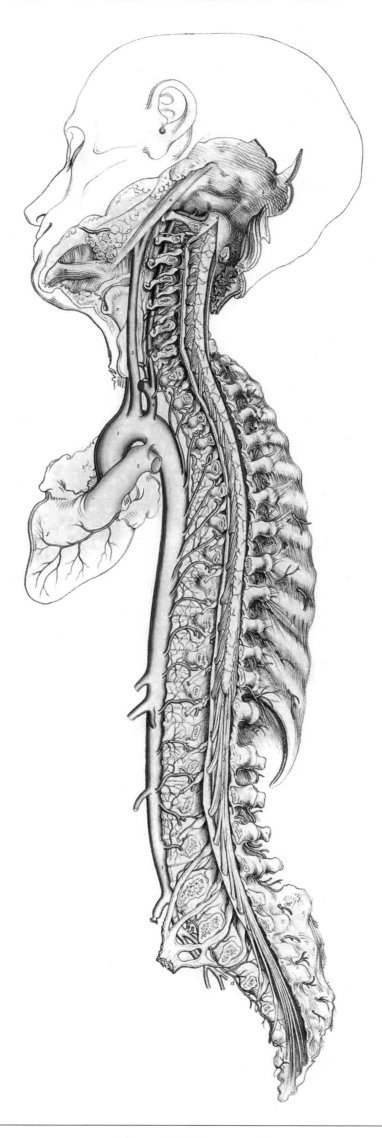

**Illustration showing the arteries which enter the spinal canal
from different sources, for the supply of the spinal cord and bones**
Joseph Maclise, *The anatomy of the arteries of the human body and its applications
to pathology and operative surgery.* 1844.

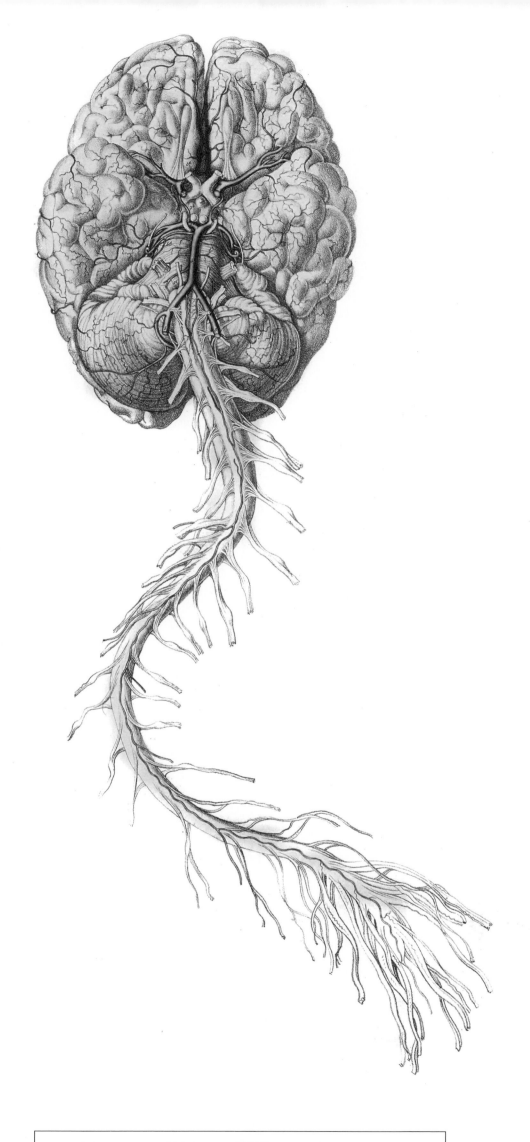

**Illustration showing the brain and spinal cord from the body of an adult male
to show the arteries at the base of the brain and the anterior spinal arteries**
Joseph Maclise, *The anatomy of the arteries of the human body and its applications
to pathology and operative surgery*. 1844.

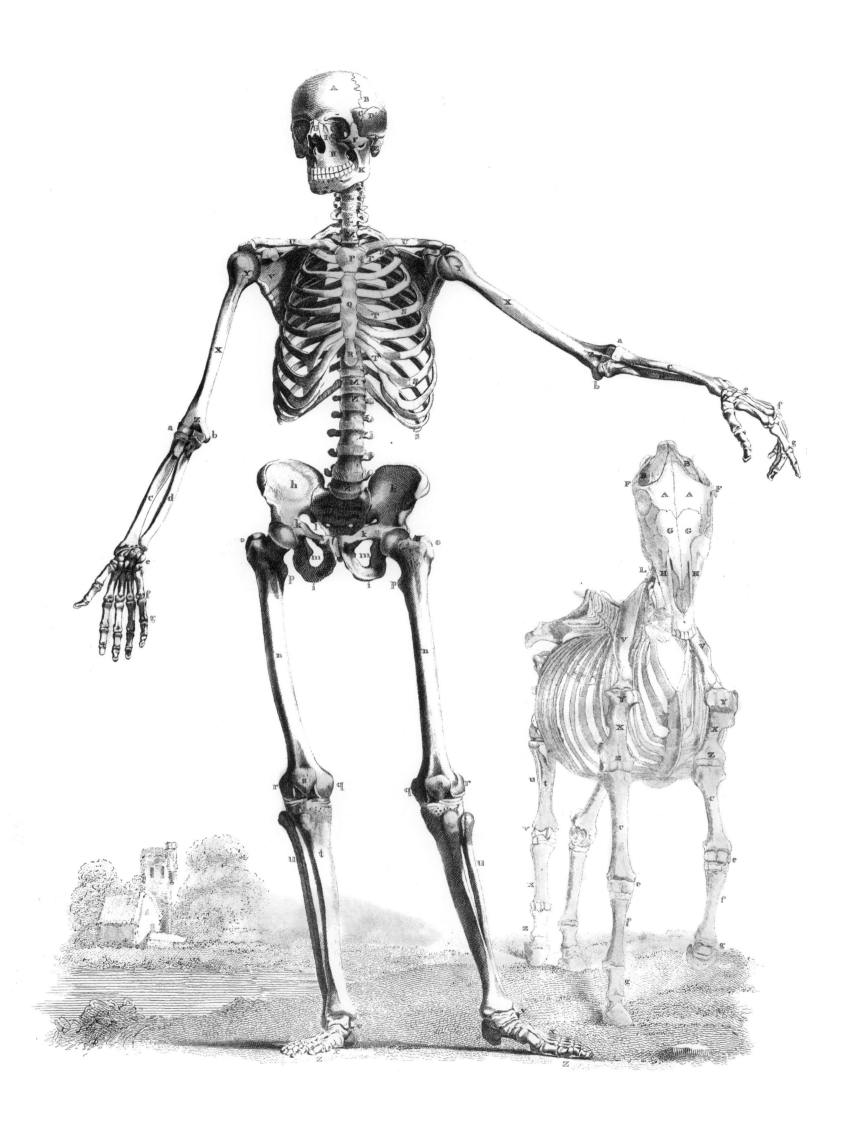

Male skeleton with horse
Sue, *The anatomy of the bones of the human body.* 1829.

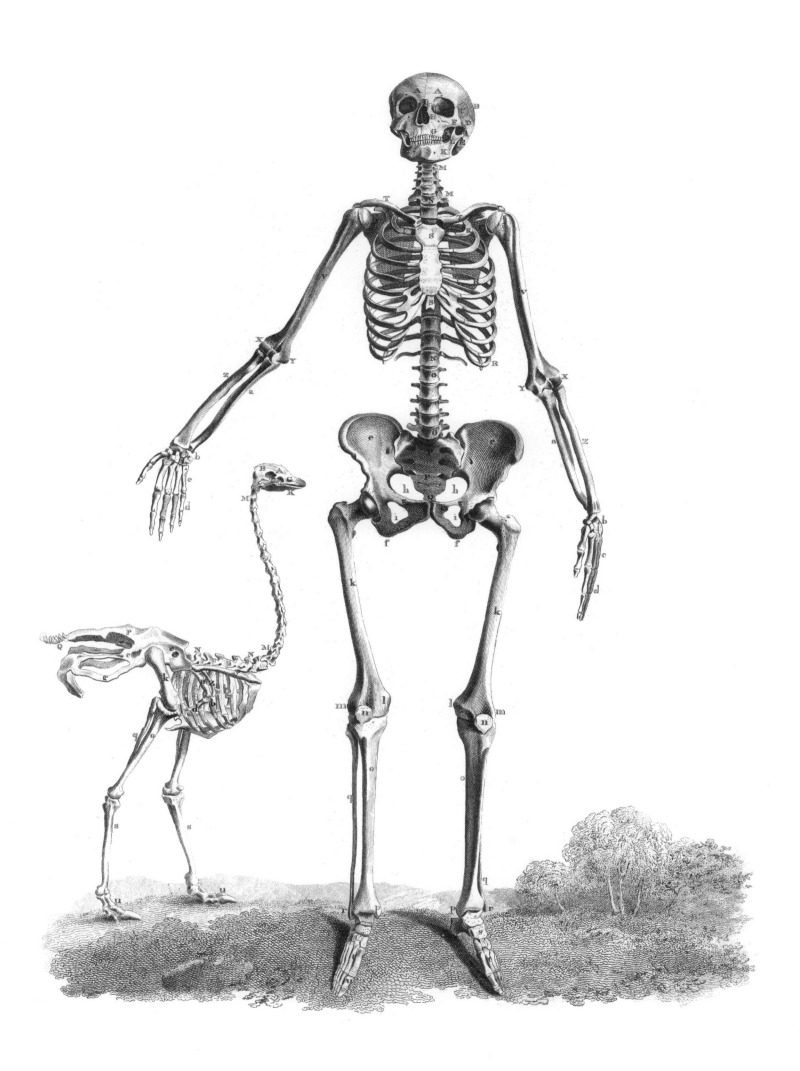

Female skeleton with ostrich
Sue, *The anatomy of the bones of the human body.* 1829.

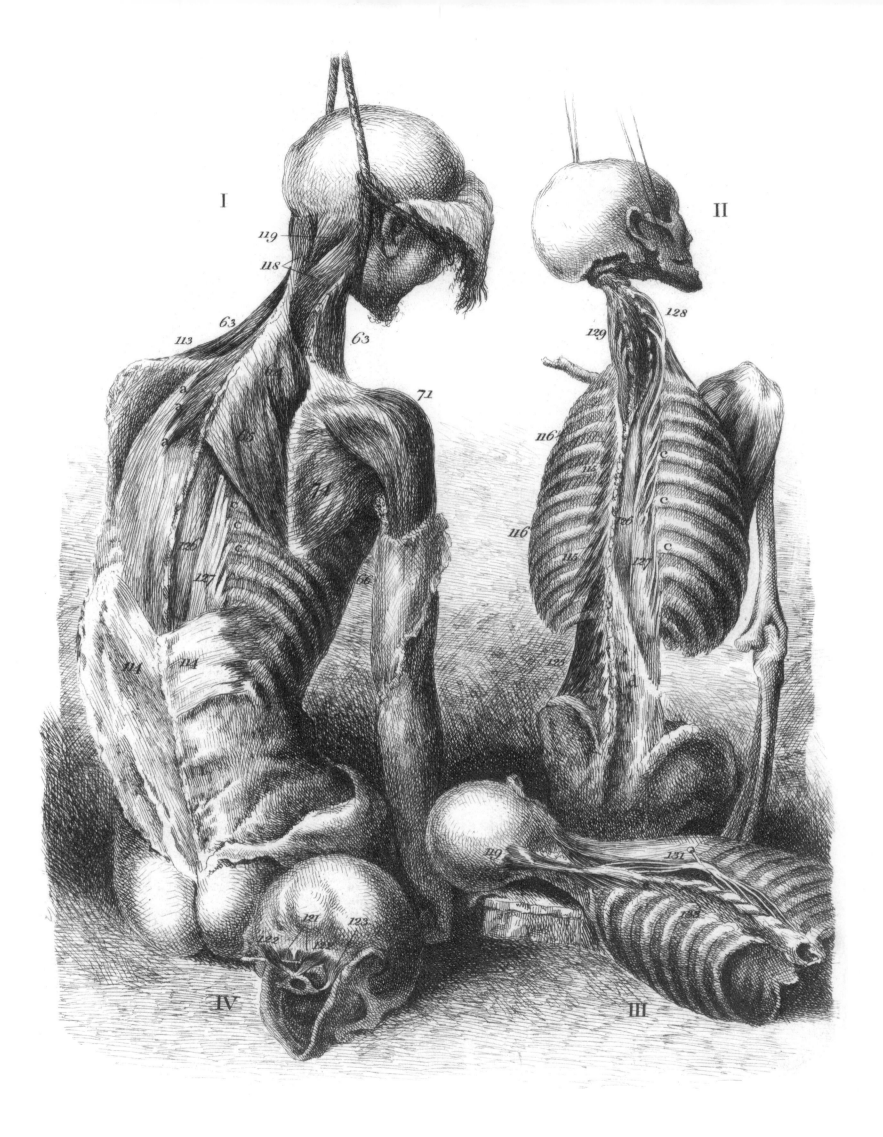

Two anatomical illustrations showing muscles and bones of the back
John Bell, engravings of the bones, muscles, and joints, illustrating the first volume
of the *Anatomy of the human body*. 1804.

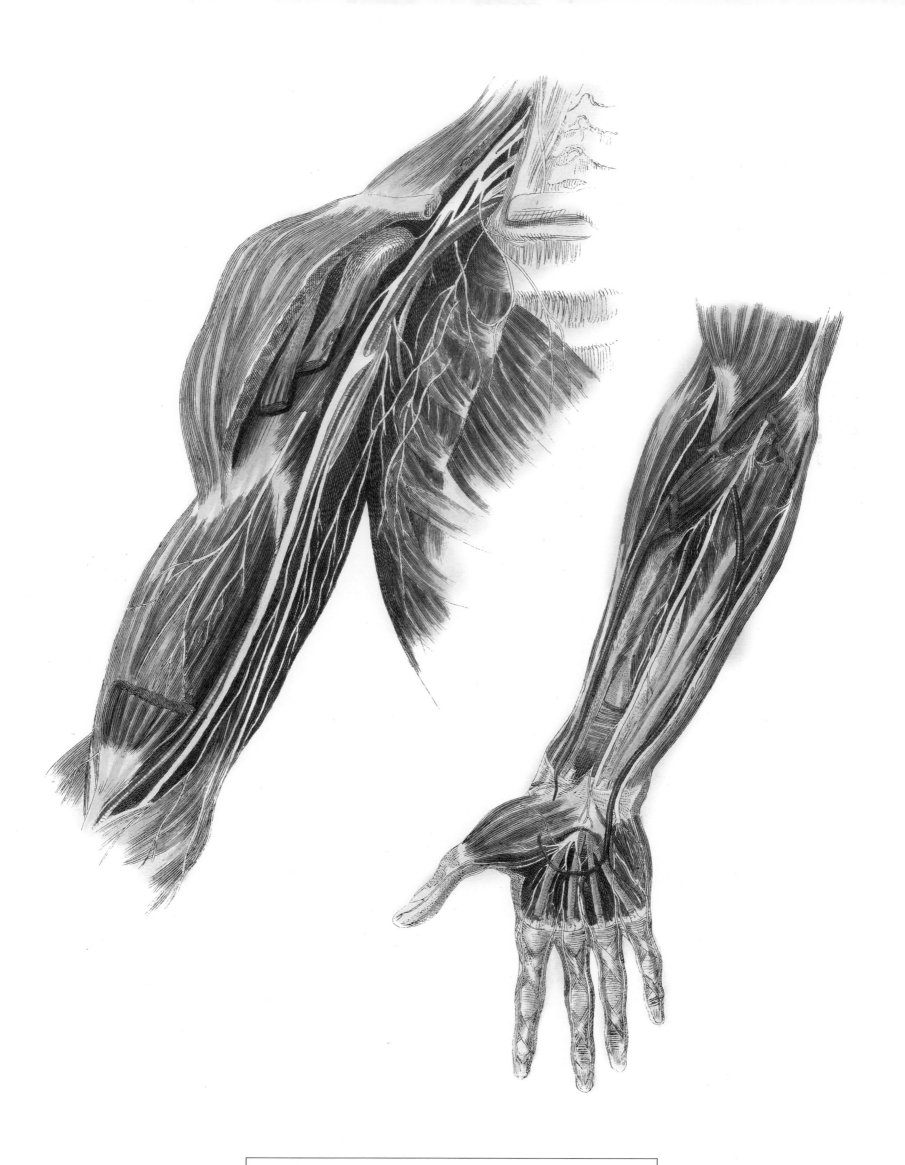

Shoulder and arm
Frederic John Mouat, *An atlas of anatomical plates of the human body.* 1849.

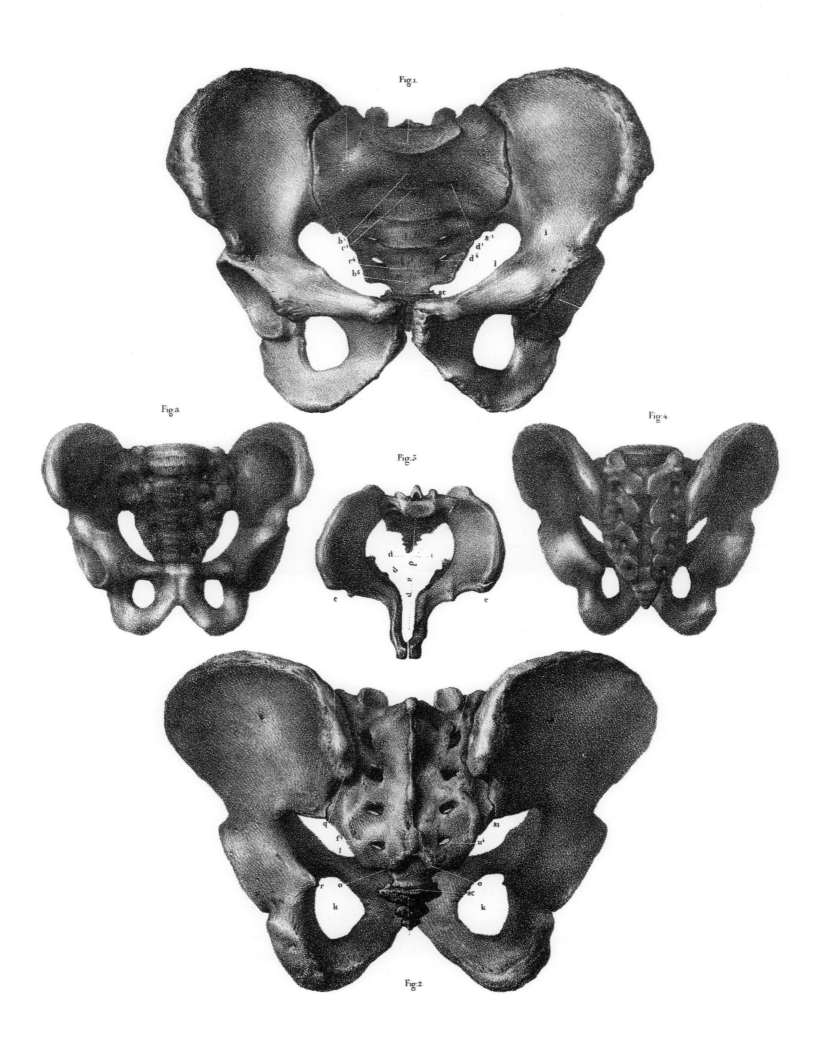

The pelvis: five figures

Nicolas-Henri Jacob, *Lithograph.* 1831-1854.

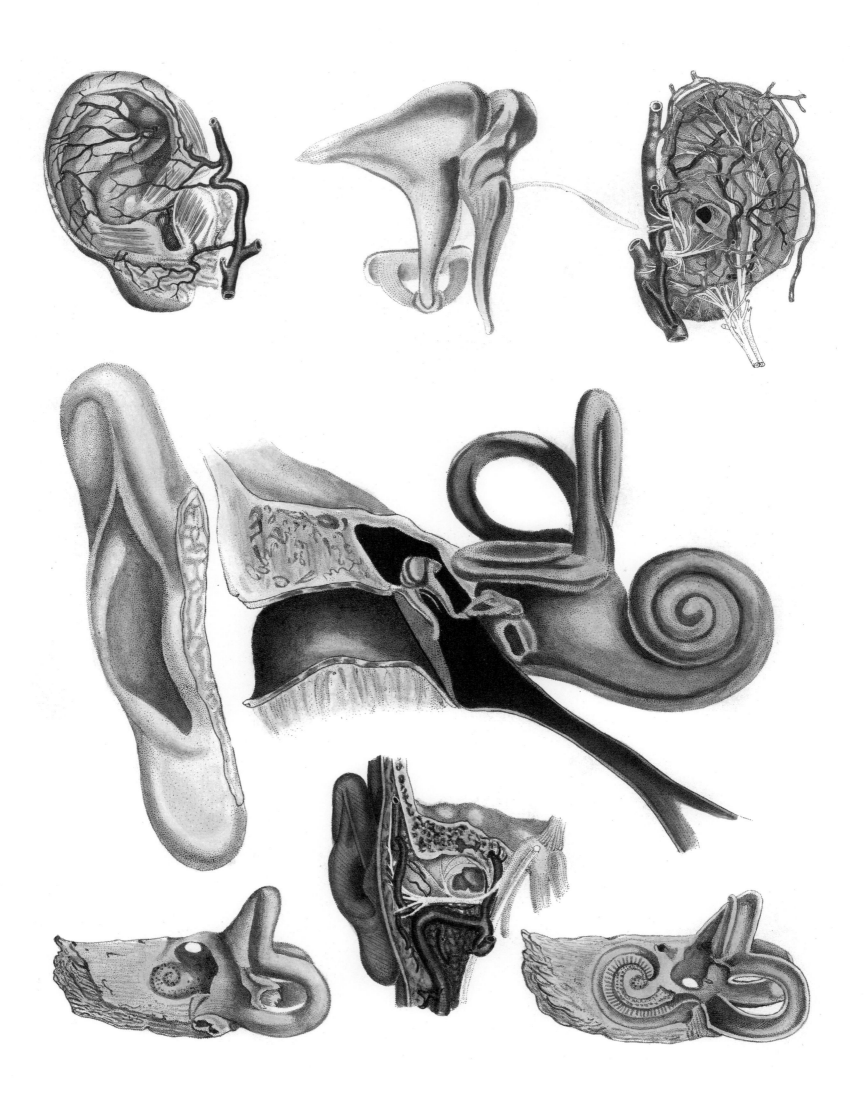

The auditory system
Frederic John Mouat, *An atlas of anatomical plates of the human body.* 1849.

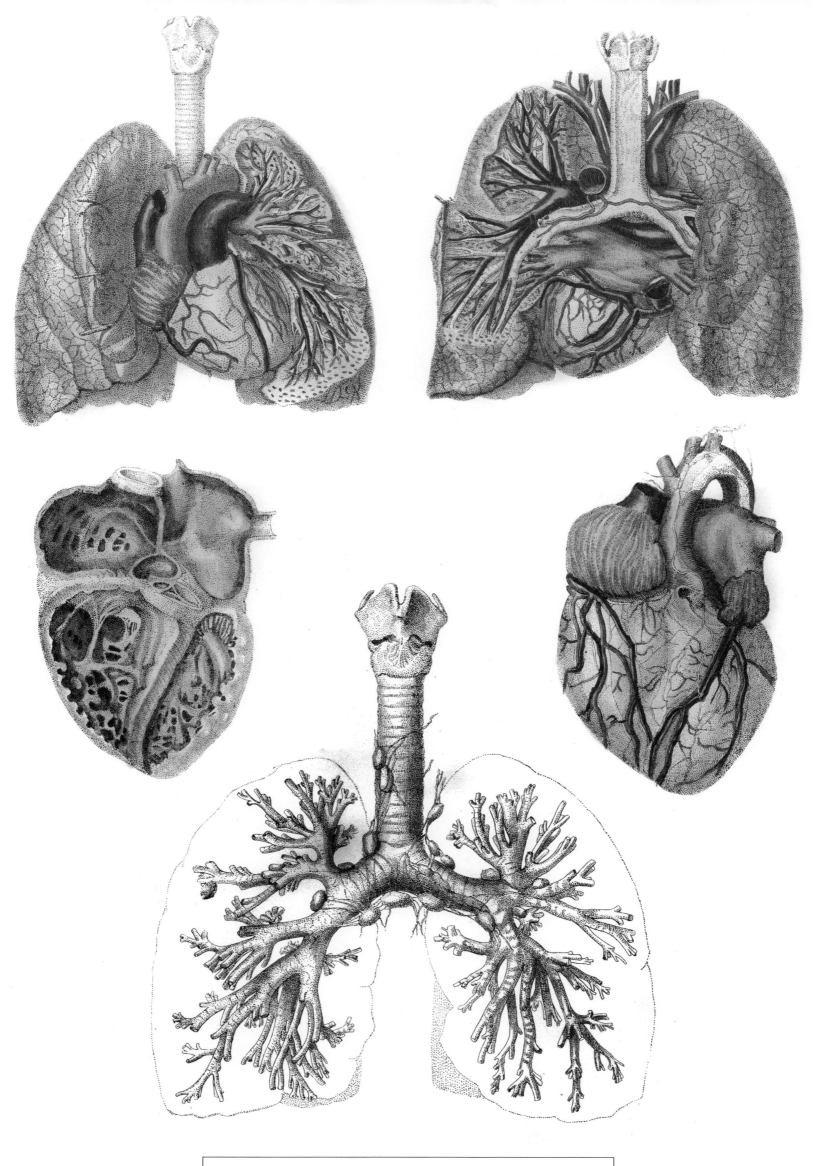

Lungs

Frederic John Mouat, *An atlas of anatomical plates of the human body*. 1849.

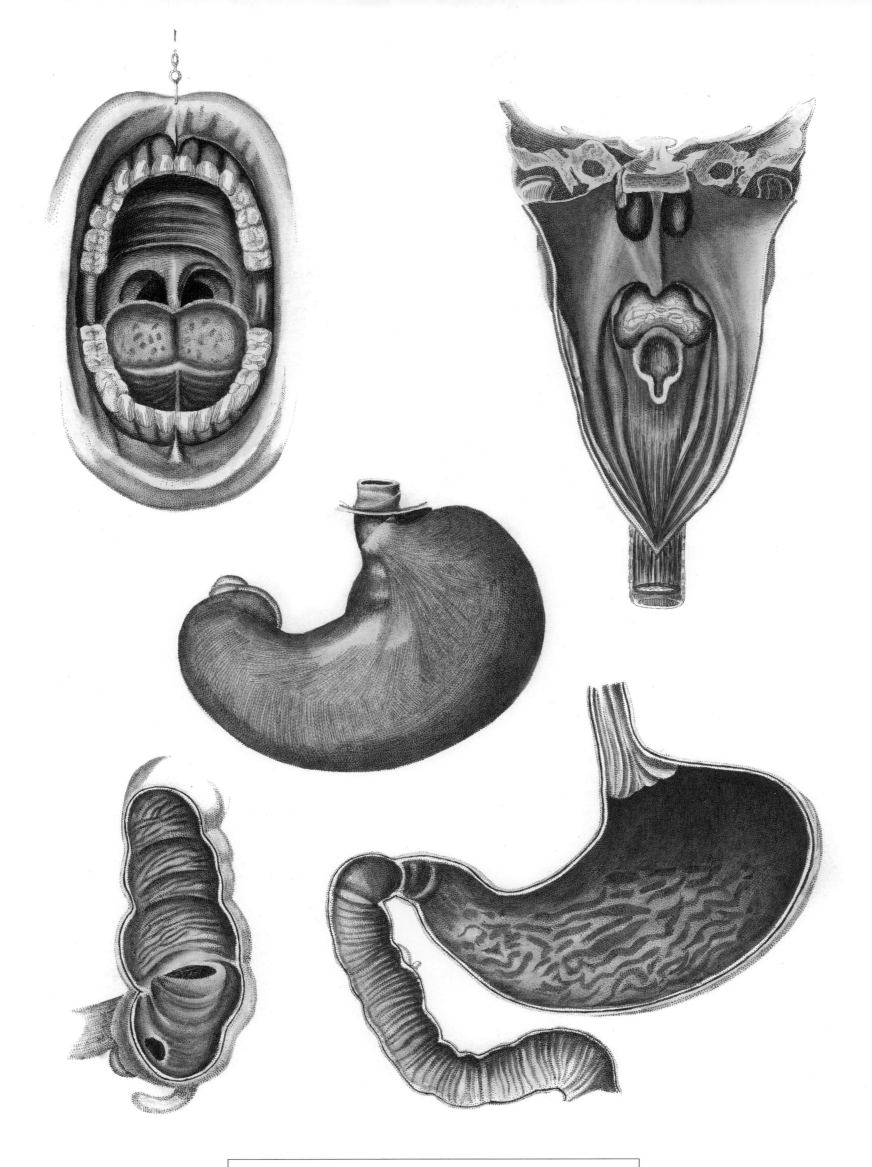

The digestive system
Frederic John Mouat, *An atlas of anatomical plates of the human body*. 1849.

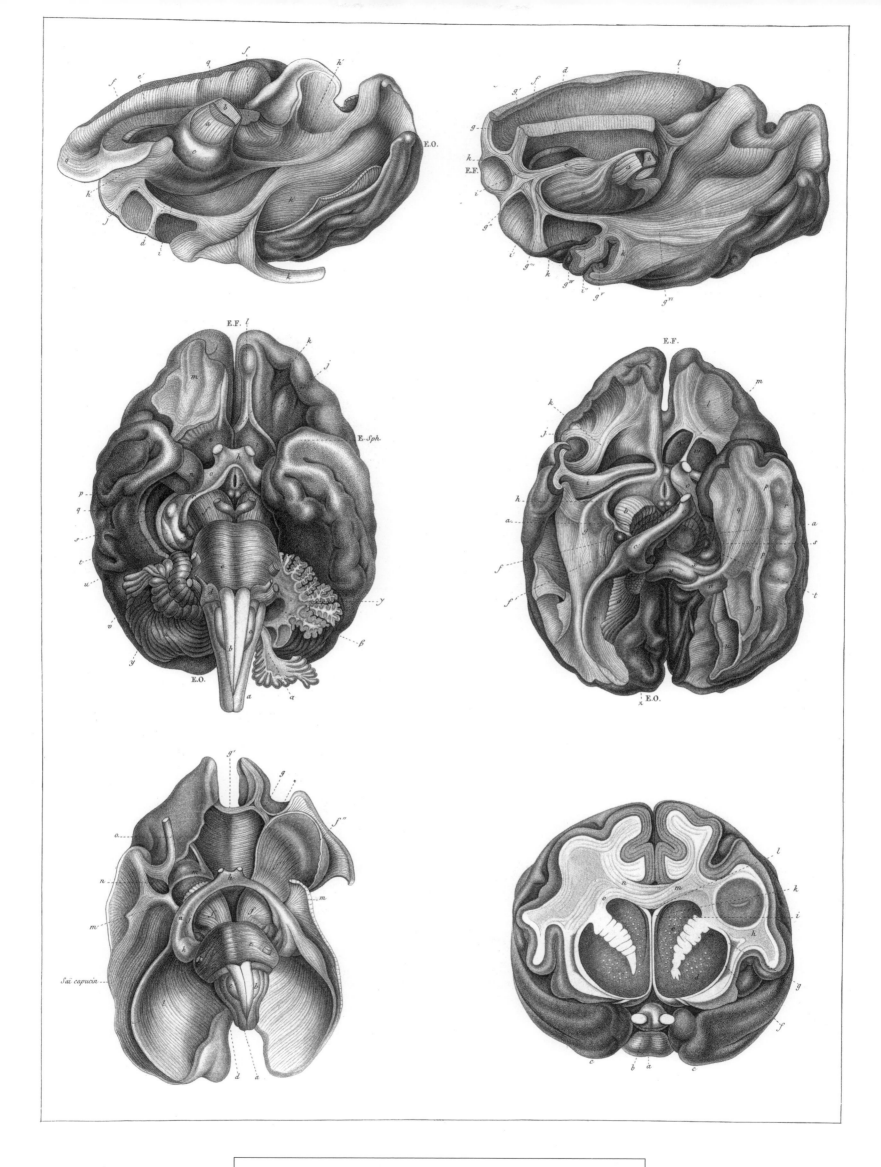

Comparative anatomy of the nervous system in relationship with intelligence
François Leuret, *The Atlas*. 1839.

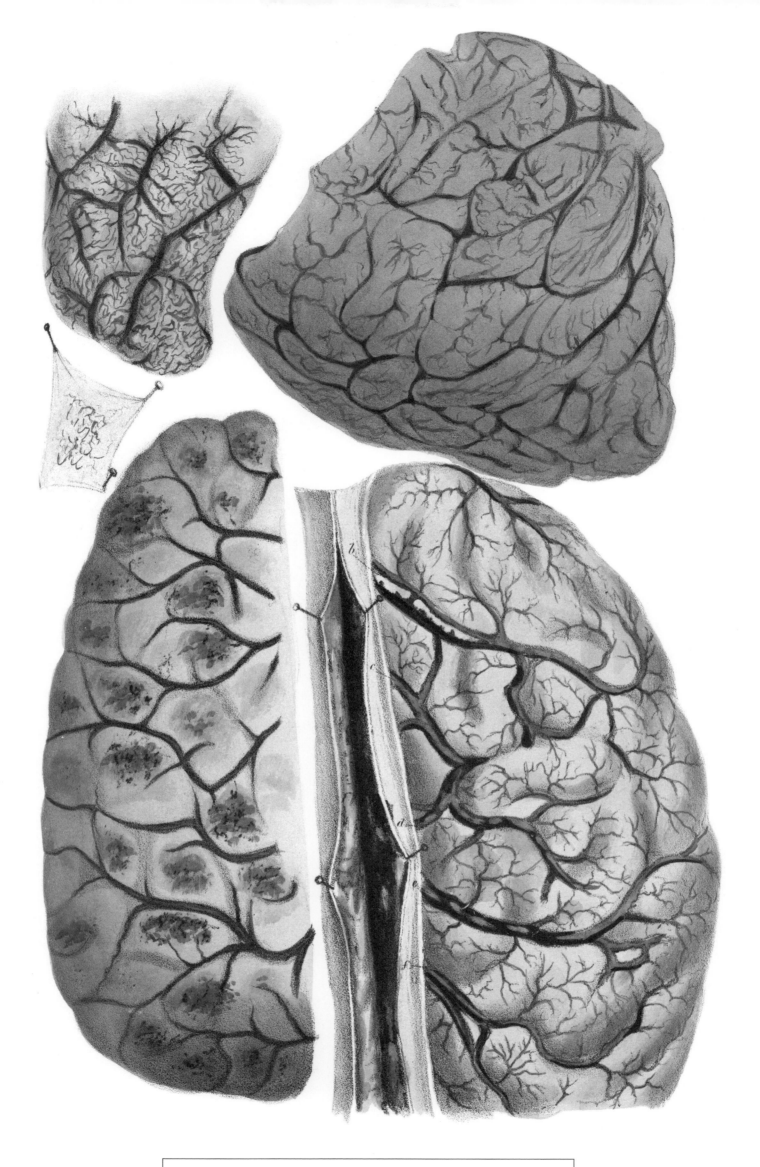

Dissection of tubercular brains
James Hope, *Principles and illustrations of morbid anatomy.* 1834.

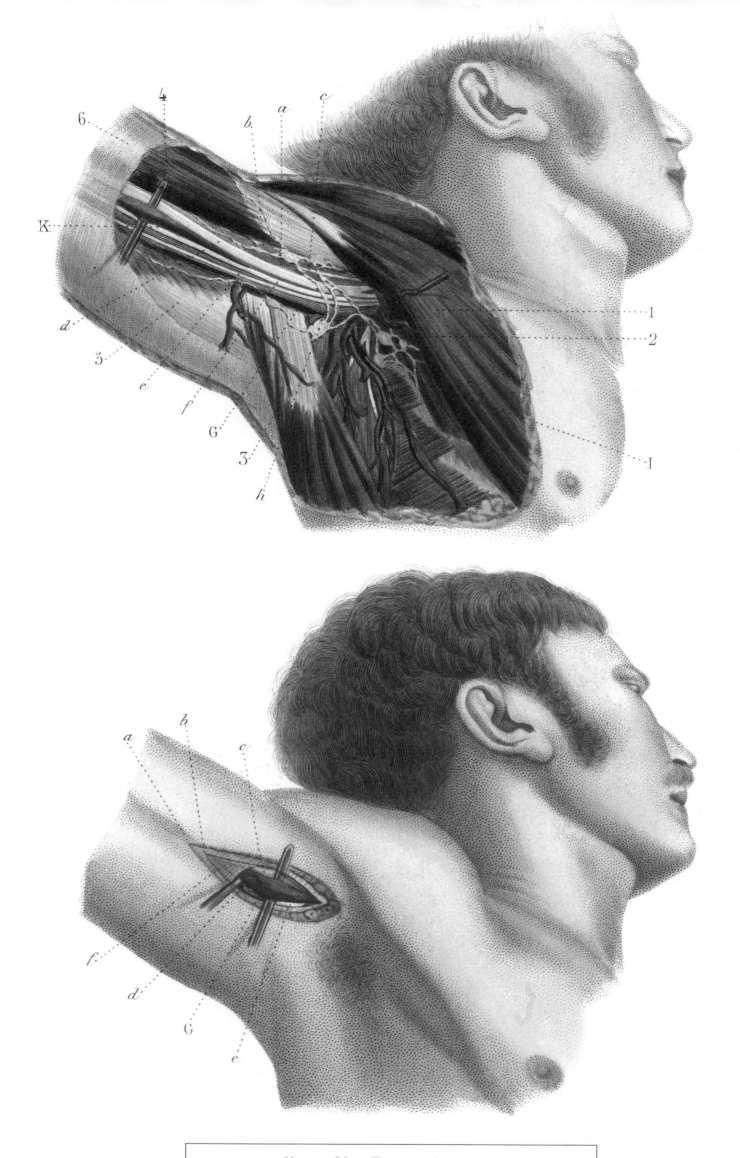

Ligature of the axillary artery in the armpit
Claude Bernard and Charles Huette, *Précis iconographique de médecine opératoire et d'anatomie chirurgicale*. 1848.

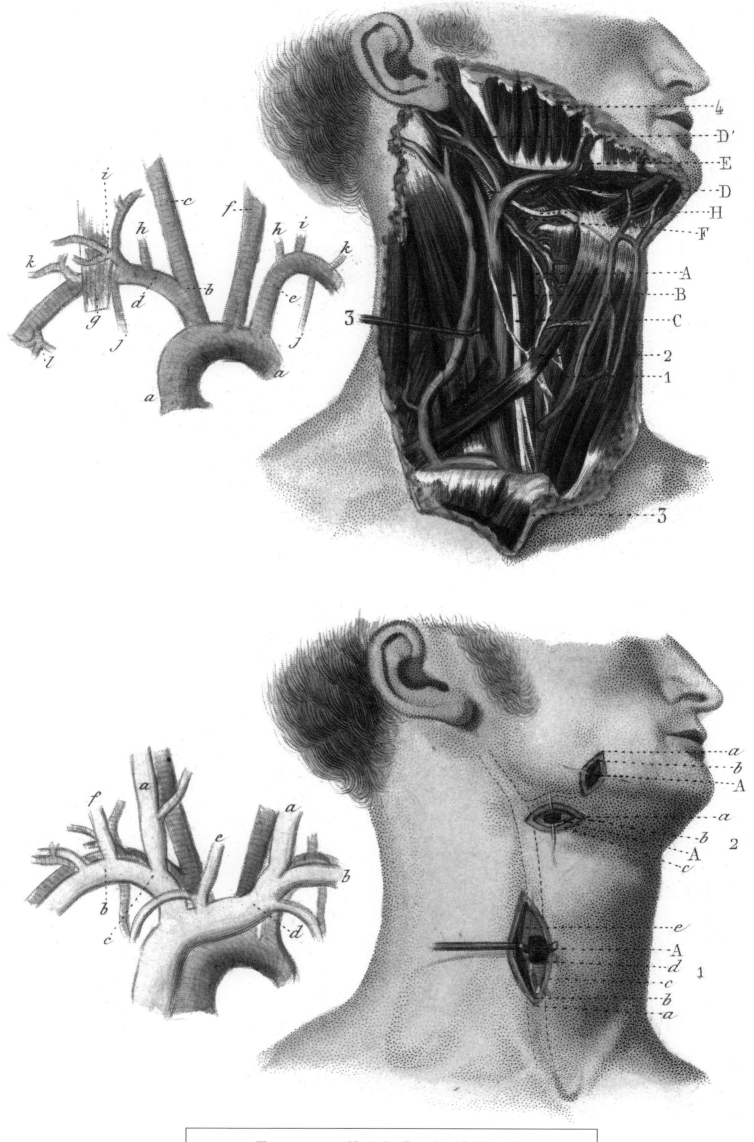

The common carotid arteries, lingual and facial arteries
Claude Bernard and Charles Huette, *Précis iconographique de médecine opératoire et d'anatomie chirurgicale*. 1848.

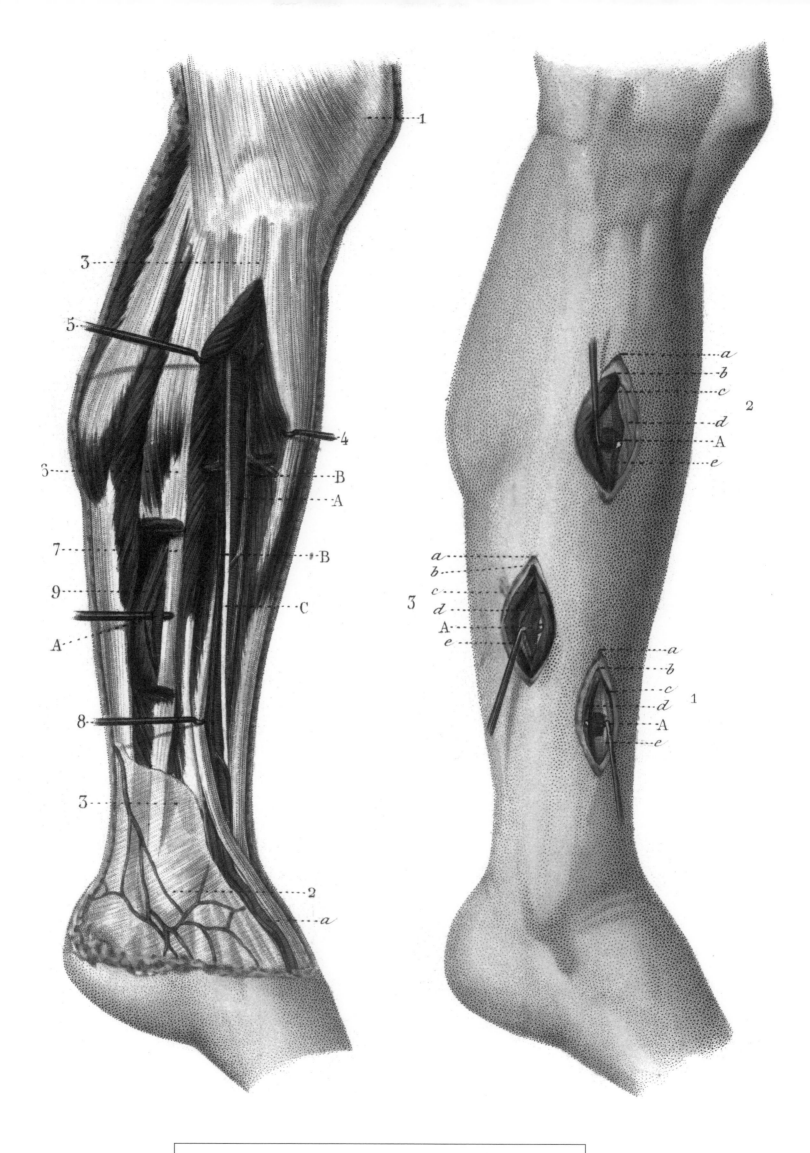

Ligature of the anterior tibial artery
Claude Bernard and Charles Huette, *Précis iconographique de médecine opératoire et d'anatomie chirurgicale.* 1848.

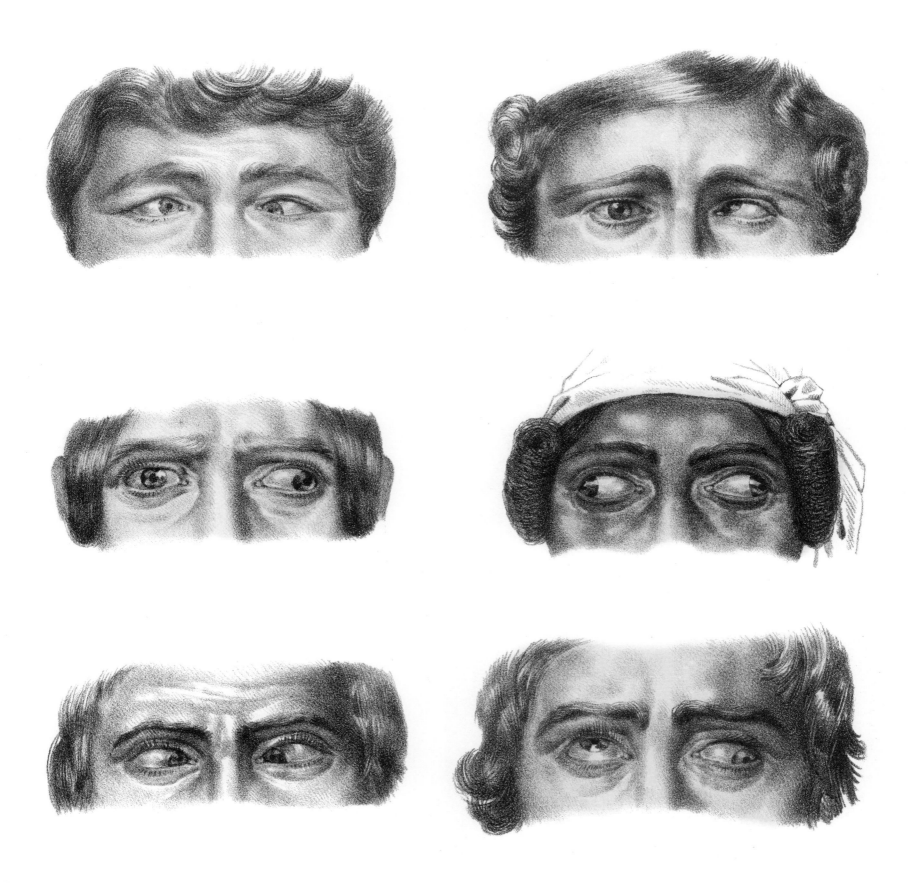

Strabismus, a condition when the eyes are not aligned with each other.
Surgical anatomy of the muscles of the eye
Nicolas-Henri Jacob, *Traité complet de l'anatomie de l'homme comprenant la médecine opératoire.* 1840.

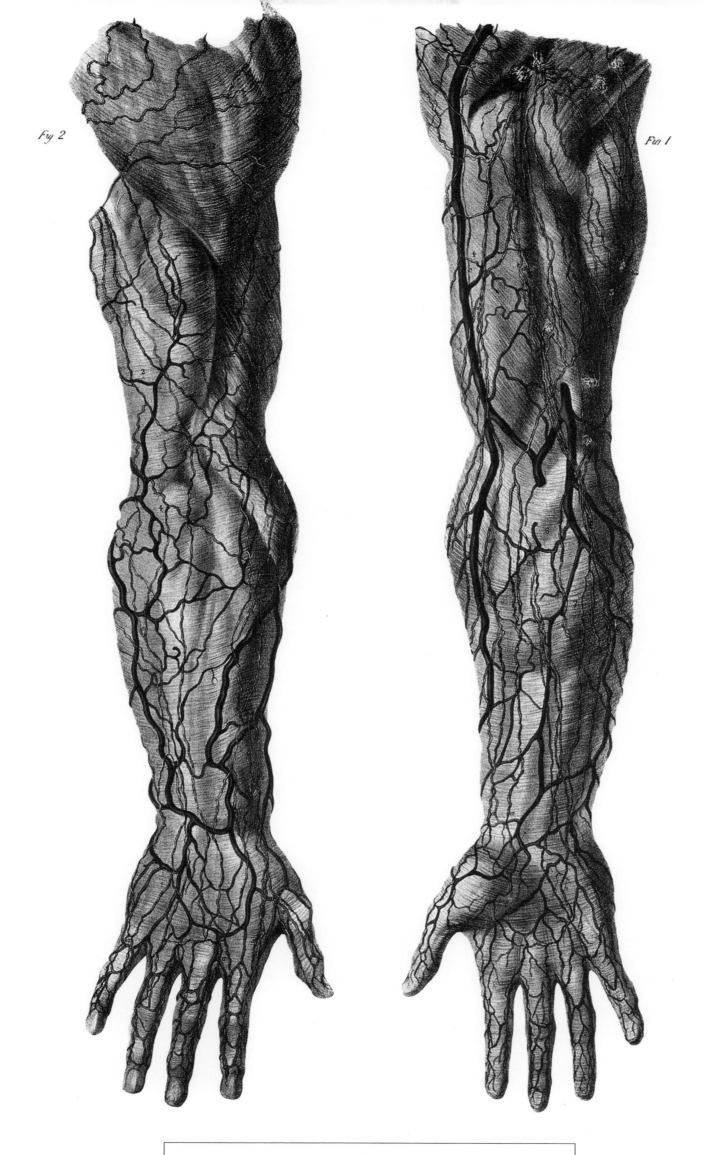

Fig 2

Fig 1

Arm
Erasmus Wilson, after Jones Quain, William T. Fairland and J. Walsh,
Lithograph published by Taylor & Walton. 1837.

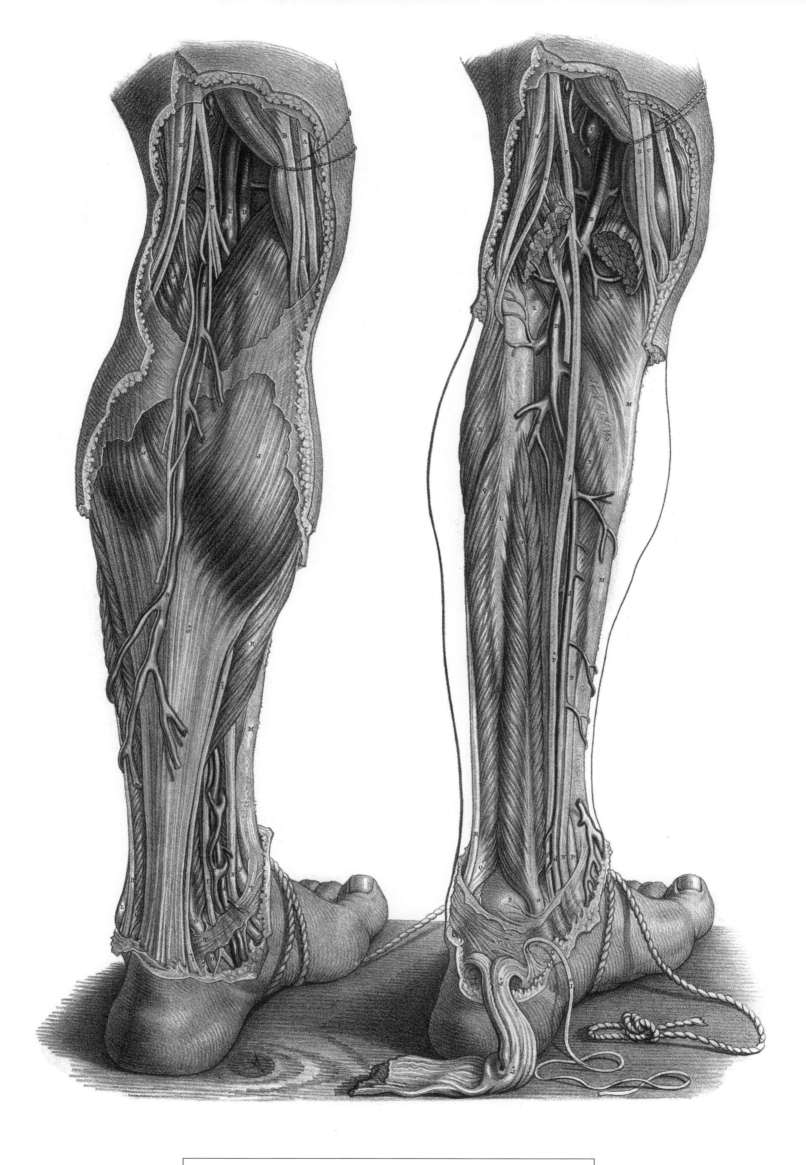

Dissection of the leg, ankle and foot
Joseph Maclise, *Surgical anatomy*. 1856.

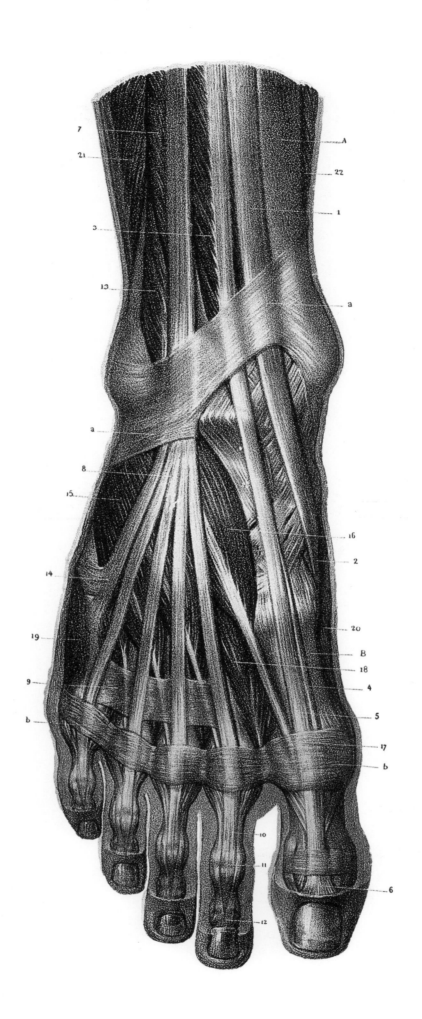

Muscles and tendons of the foot
Nicolas-Henri Jacob, Lithograph. 1831-1854.

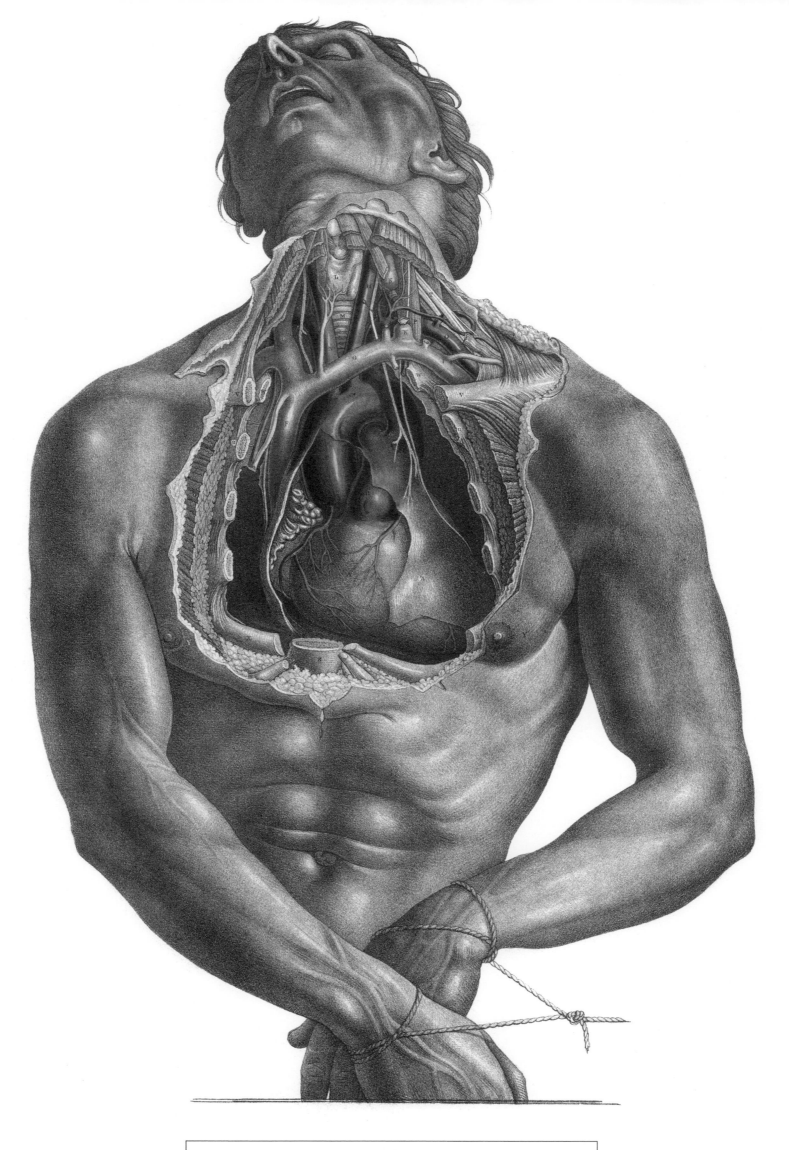

**The surgical dissection of the thorax and the episternal region.
Delegation of the primary aortic branches**
Joseph Maclise, *Surgical anatomy*. 1856.

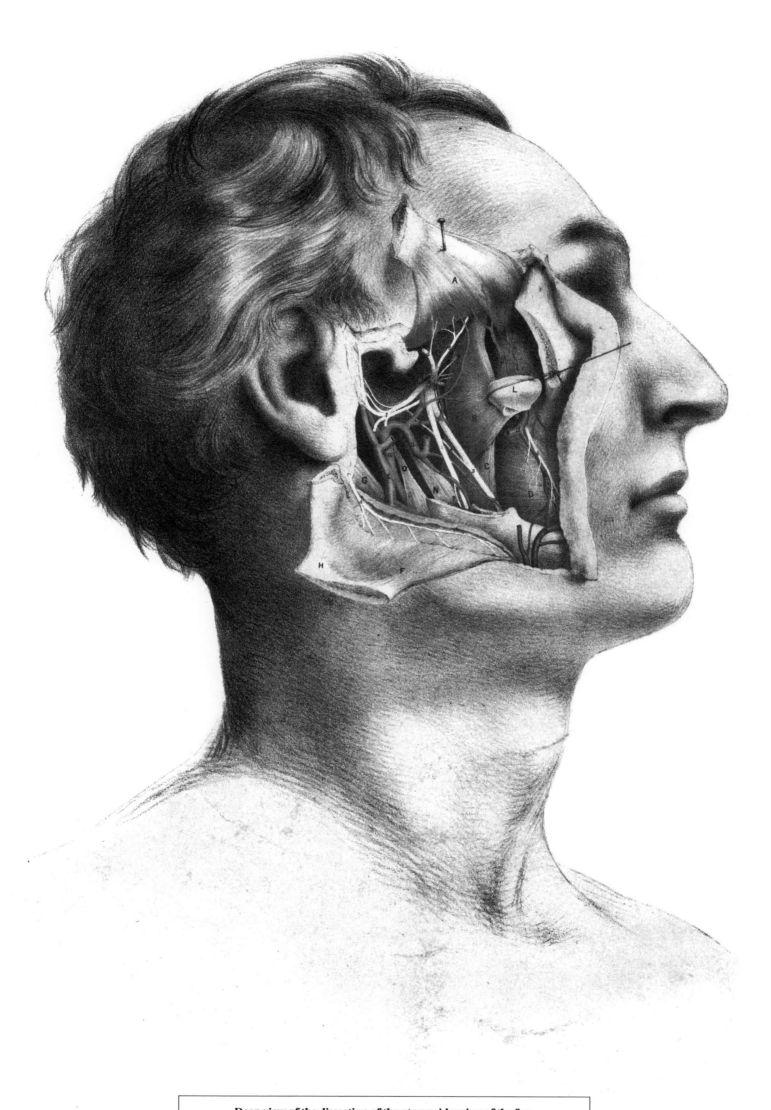

Deep view of the dissection of the pterygoid region of the face
George Viner Ellis, *Illustrations of dissections in a series of original coloured plates*. 1876.

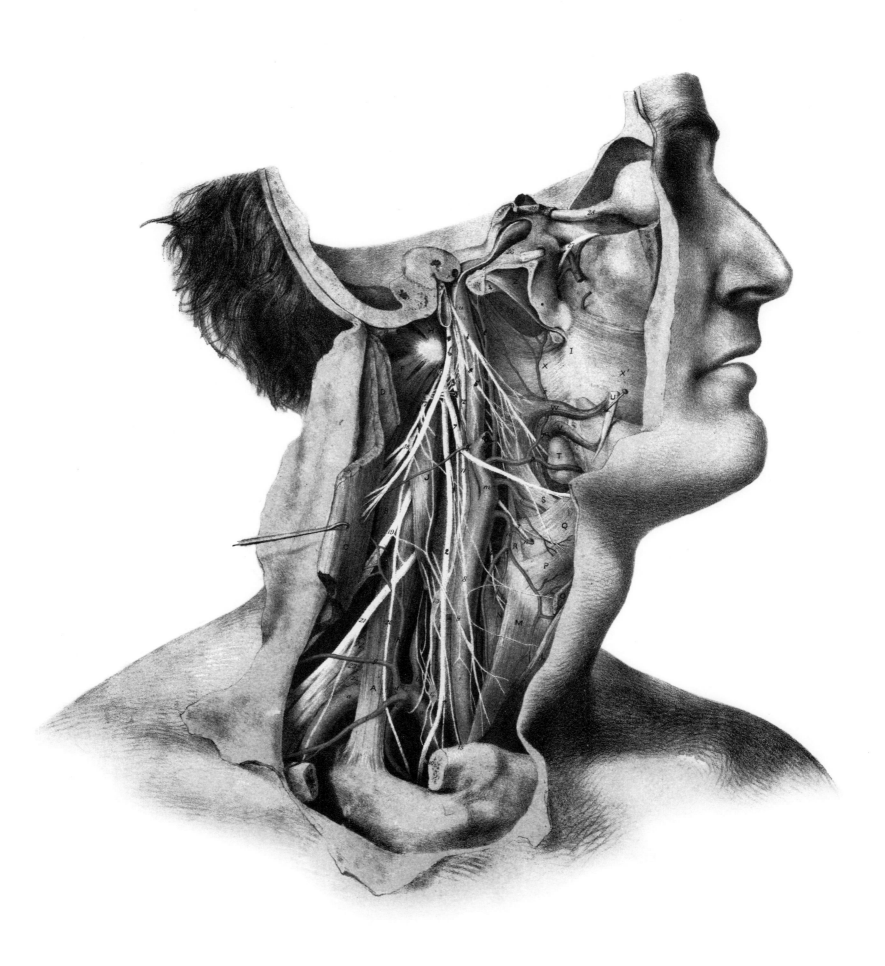

Dissection showing the internal carotid artery, ascending pharyngeal artery, and cranial nerves in the neck

George Viner Ellis, *Illustrations of dissections in a series of original coloured plates.* 1876.

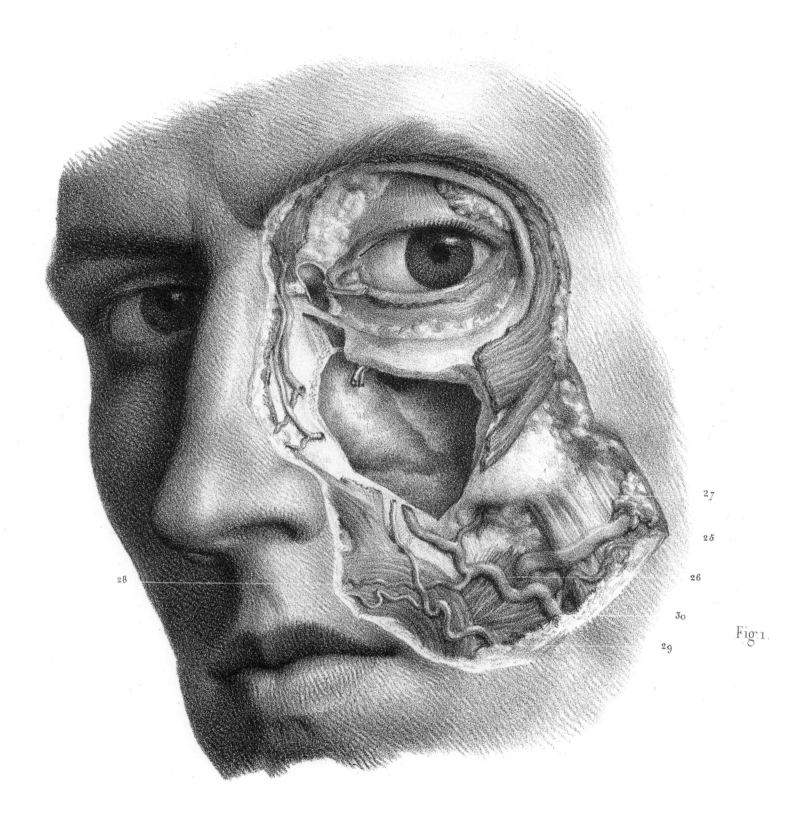

27

25

28

26

30

29

Fig 1.

Catheterisations of the cavities and ducts of the head. Nasal and oral cavities
Nicolas-Henri Jacob, *Traité complet de l'anatomie de l'homme comprenant la médecine opératoire.* 1840.

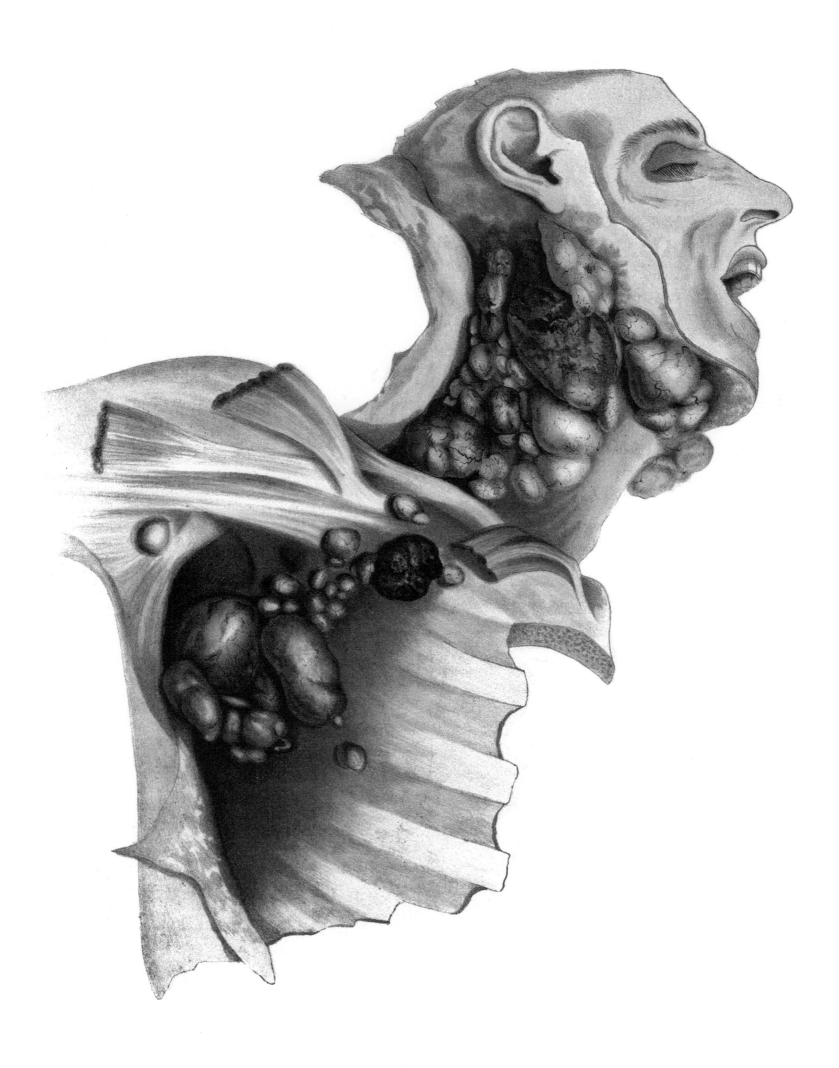

**Post-mortem view of enlarged lymphoma glands. The neck and armpit
dissected, showing enlarged glands grouped in bunches of various sizes**

New Sydenham *Society, An atlas of illustrations of pathology.* 1899.

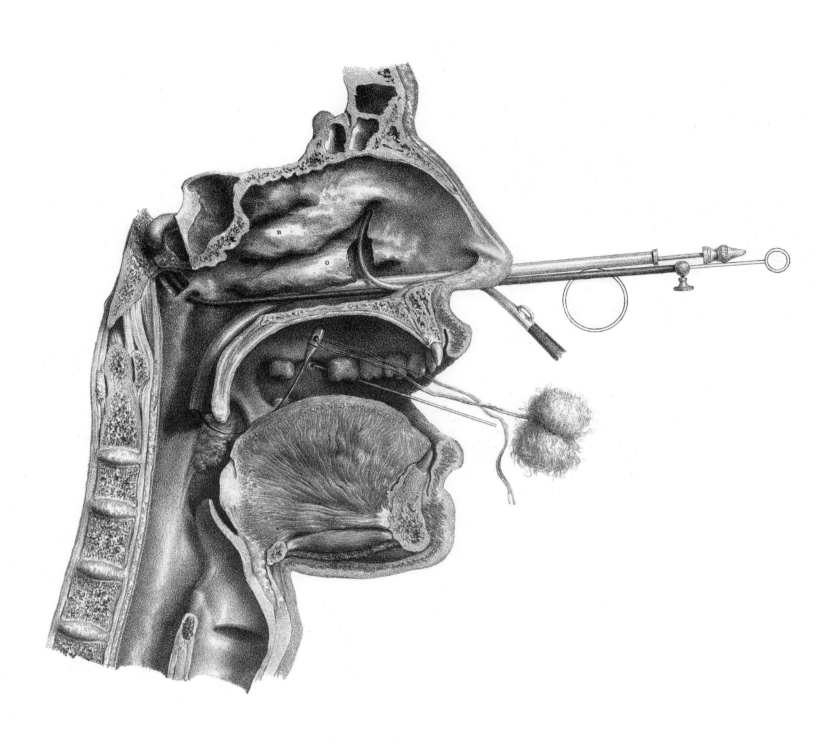

Catheterisations of the cavities and ducts of the head.
Lacrimal pathways and maxillary sinus
Nicolas-Henri Jacob, *Traité complet de l'anatomie de l'homme comprenant la médecine opératoire.* 1840.

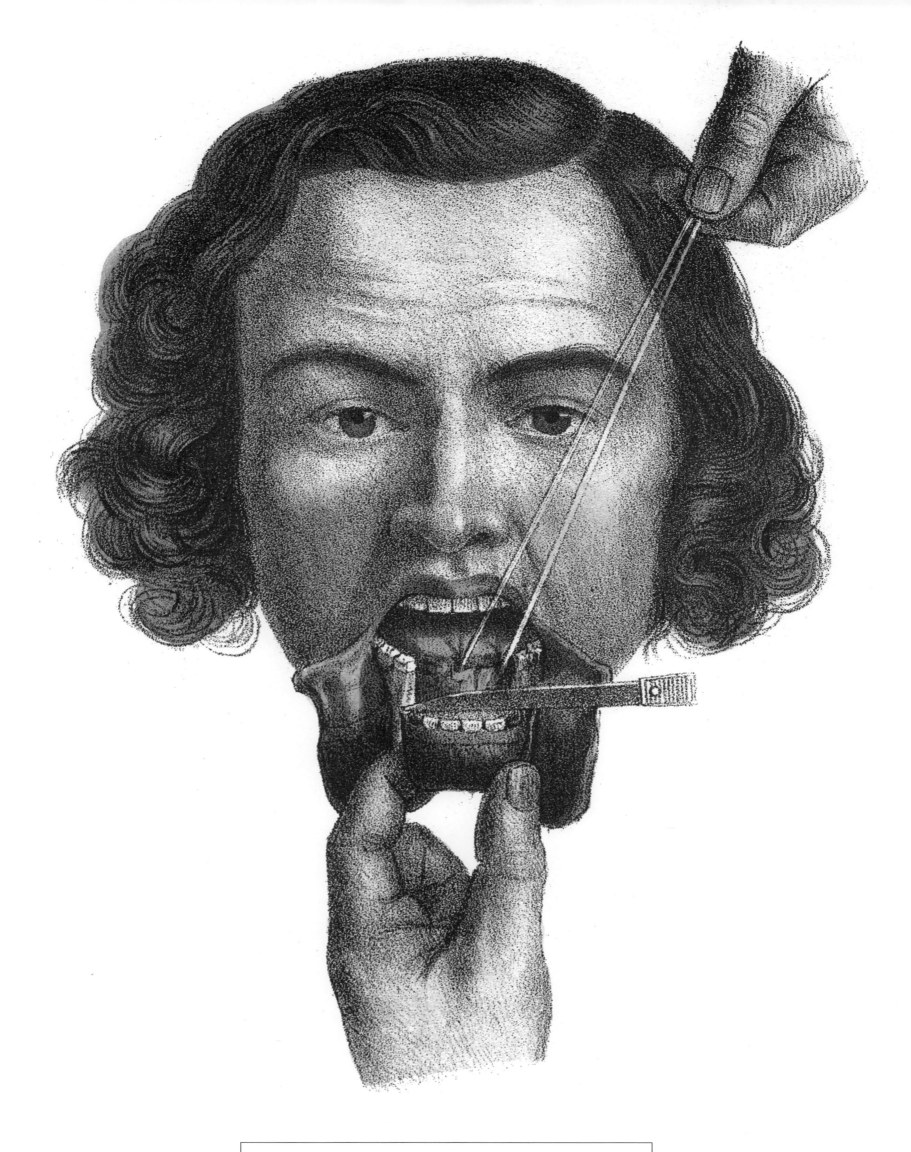

Resection of the lower jaw

Joseph Pancoast, *A treatise on operative surgery comprising a description of the various processes of the art.* 1846.

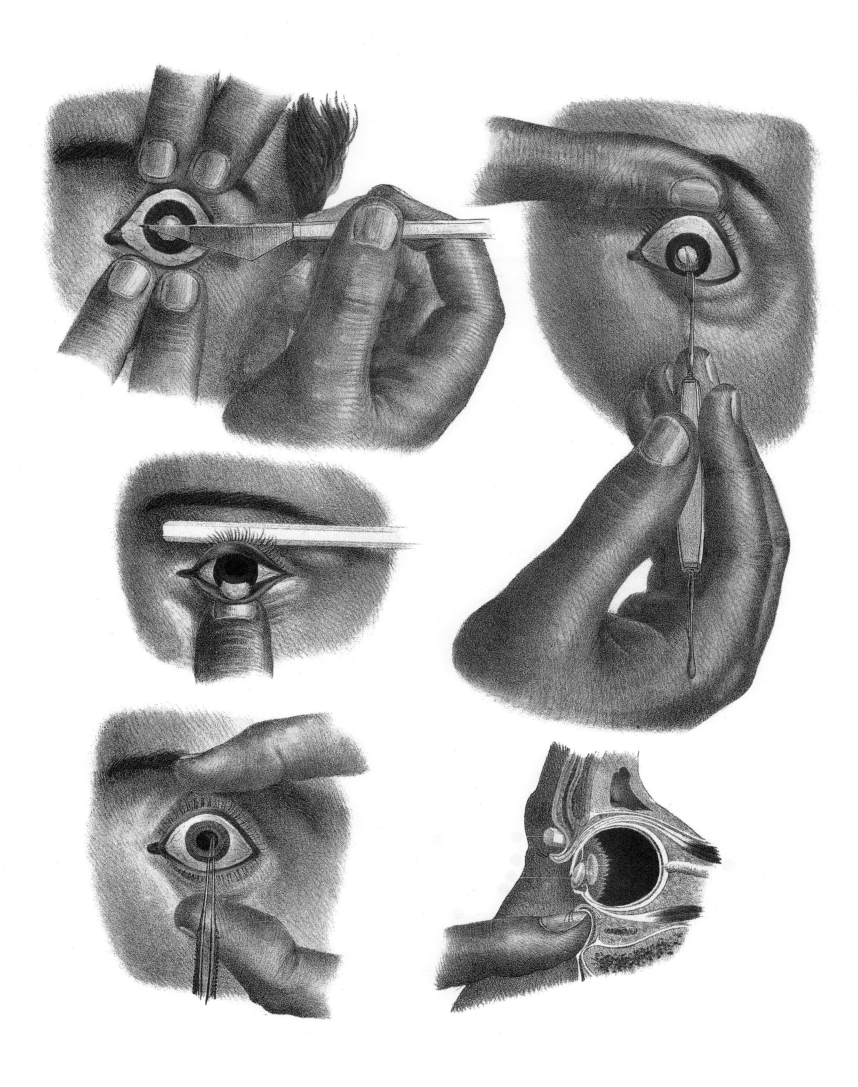

Illustration of surgery on the eye for the removal of a cataract.
Operation by exctraction – inferior section of the cornea

Joseph Pancoast, *A treatise on operative surgery*. 1846.

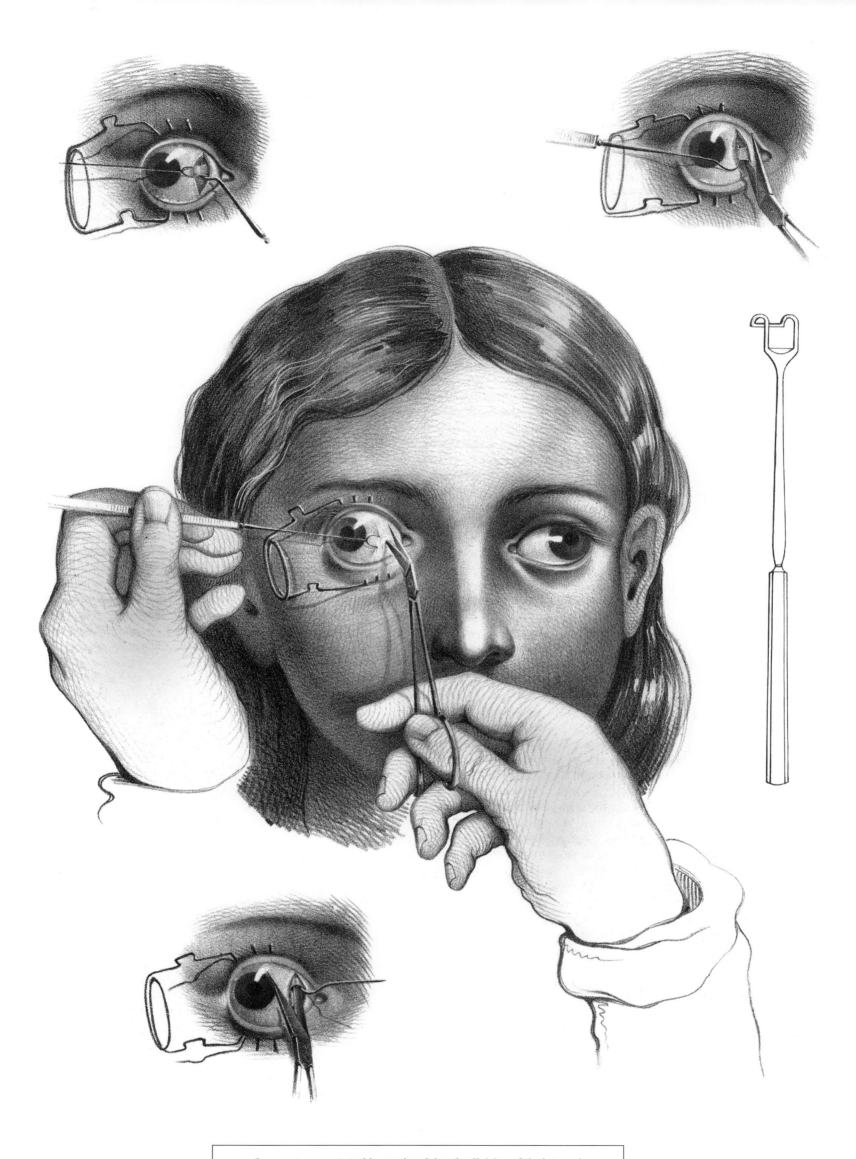

Surgery to correct strabismus, involving the division of the internal rectus of the right eye
Joseph Pancoast, *A treatise on operative surgery*. 1846.

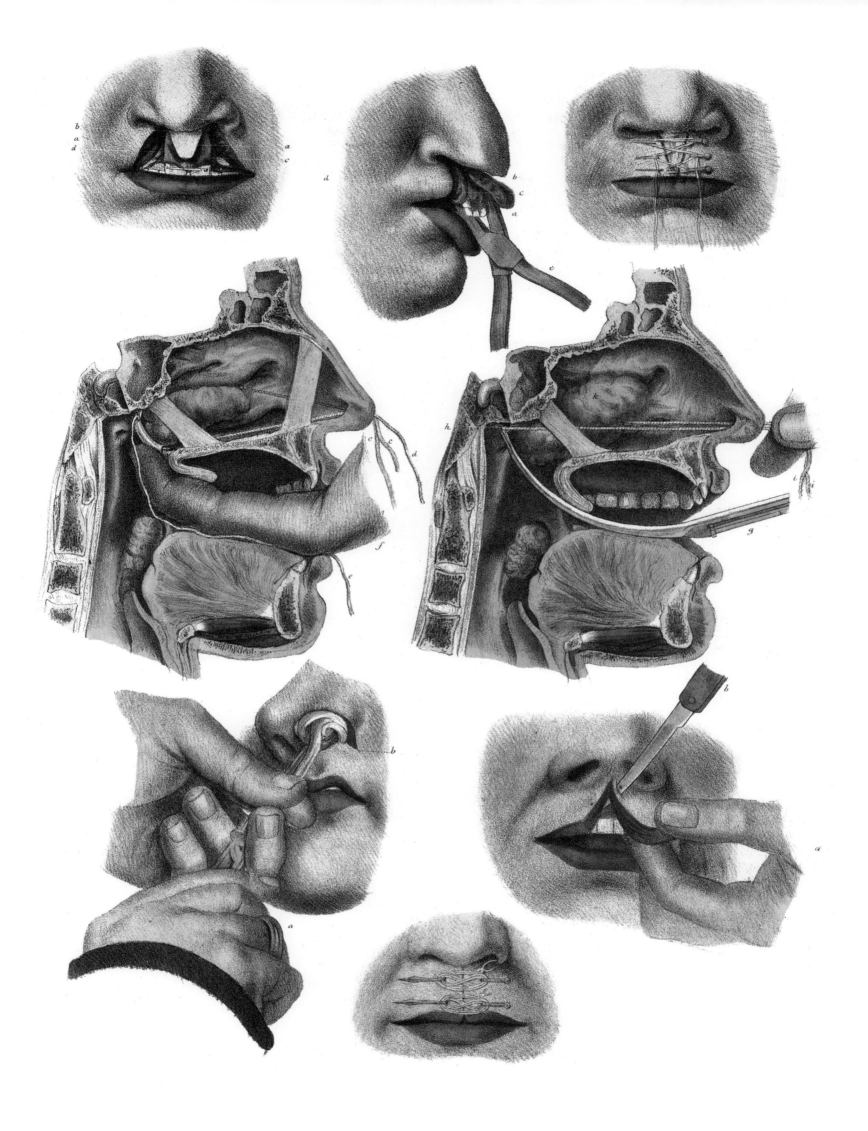

Surgical technique for nasal polypi and hare-lip
Joseph Pancoast, *A treatise on operative surgery.* 1846.

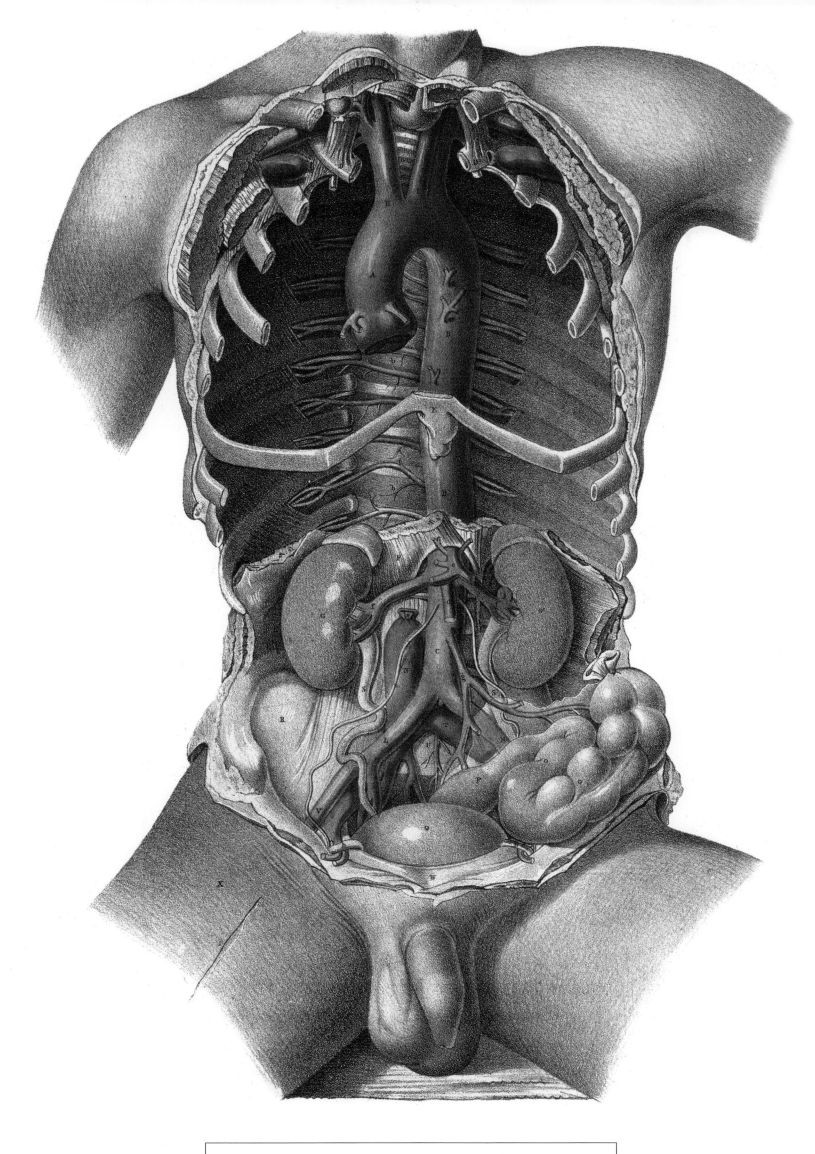

**Dissection of a man, showing the relation of the principal blood
vessels of the thorax and abdomen to the osseus skeleton**
Joseph Maclise, *Surgical anatomy*. 1859.

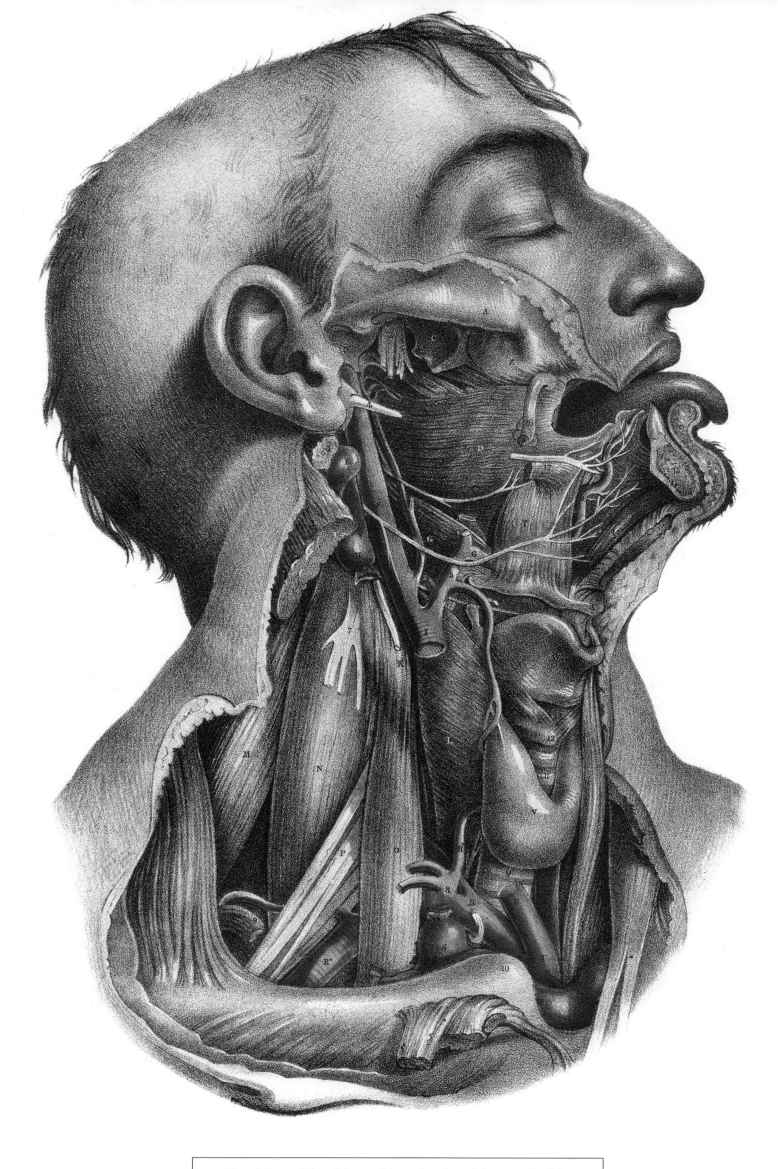

The relative position of the cranial, nasal, oral, and pharyngeal cavities
Joseph Maclise, *Surgical anatomy*. 1859.

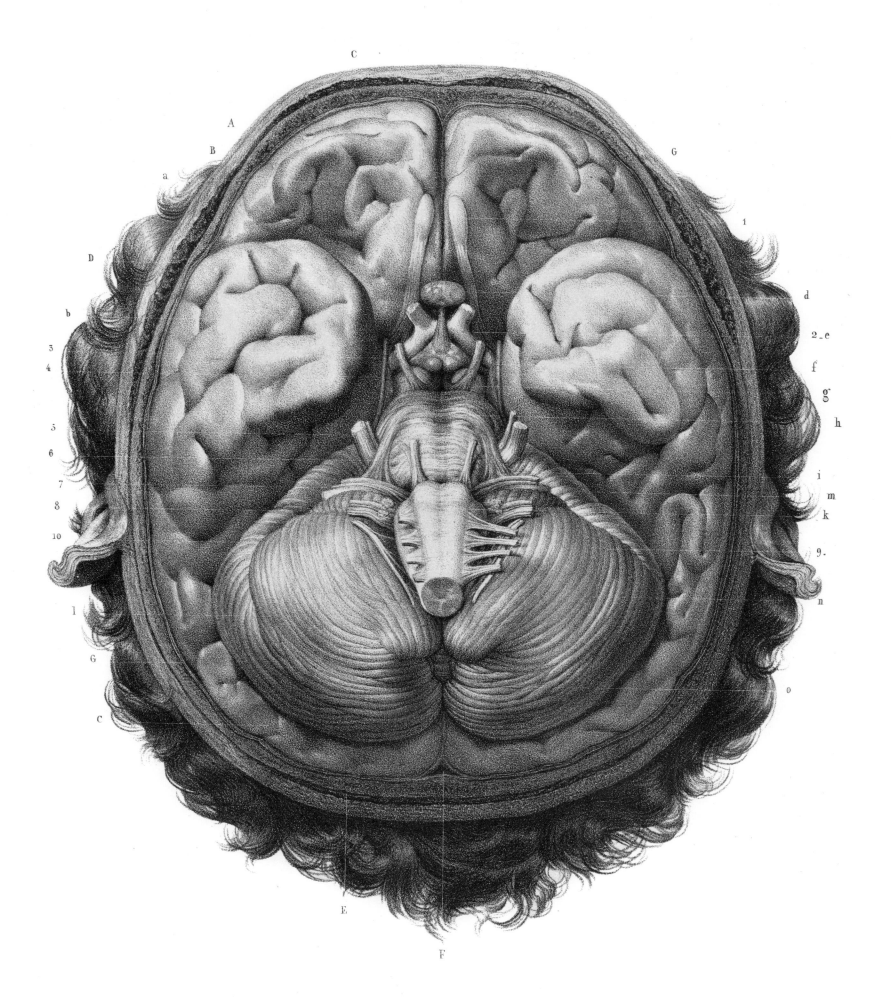

**Anatomy of the human brain shown from below,
showing the brain stem and cerebellum**
Nicolas Henri Jacob, *Traité complet de l'anatomie de l'homme comprenant
la médecine opératoire.* 1844.

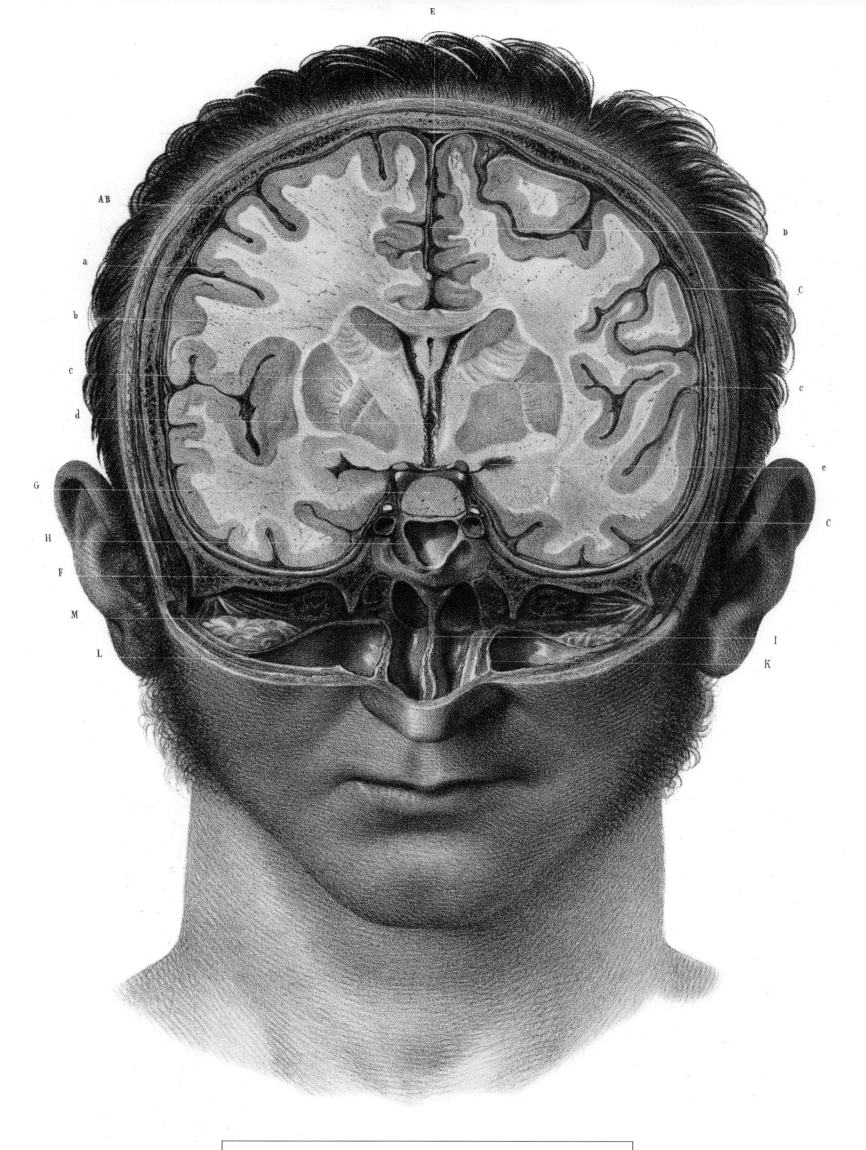

Vertical cross section of the human brain
Nicolas Henri Jacob, *Traité complet de l'anatomie de l'homme comprenant la médecine opératoire*. 1844.

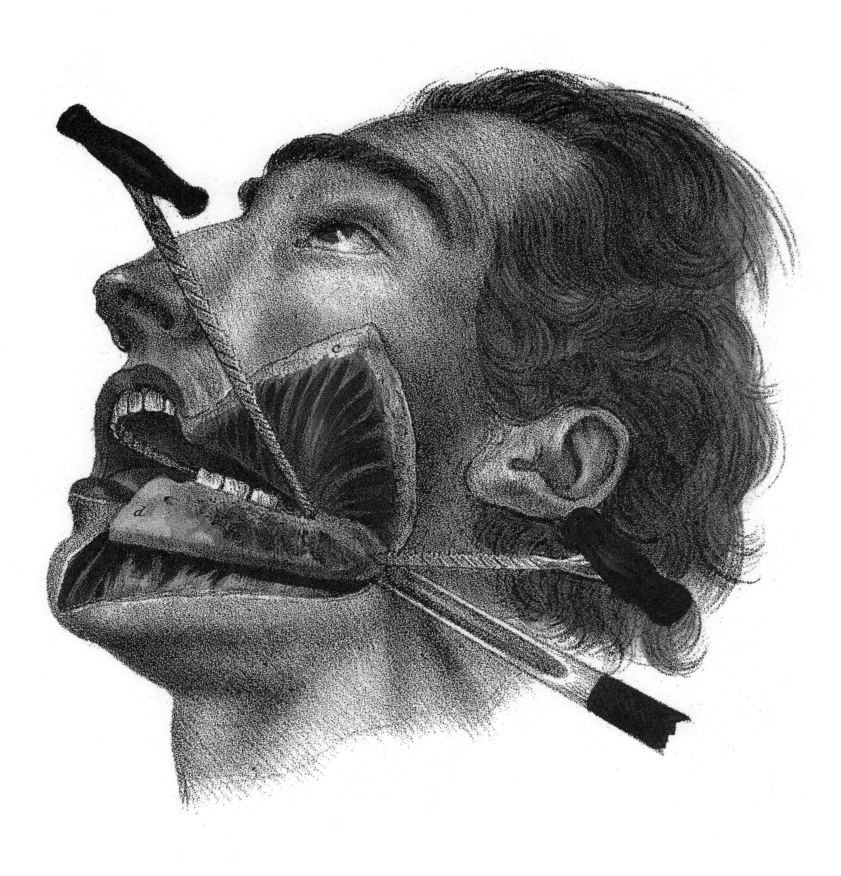

Resection of the lower jaw
Joseph Pancoast, *A treatise on operative surgery comprising a description of the various processes of the art.* 1846.

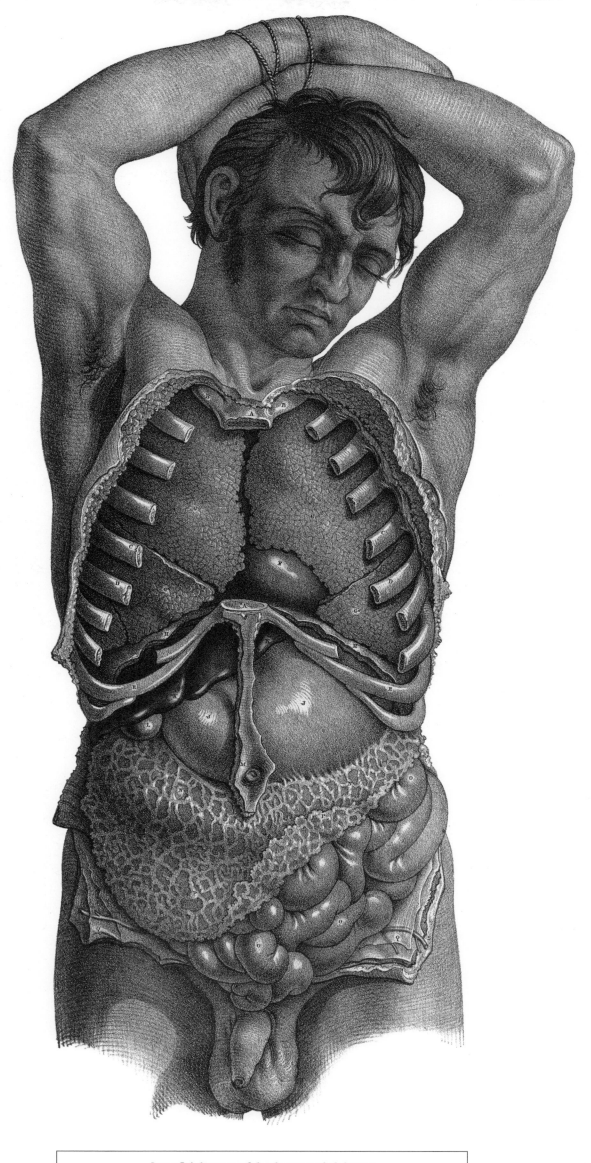

Superficial organs of the thorax and abdomen

Joseph Maclise, *Surgery anatomy.* 1856.

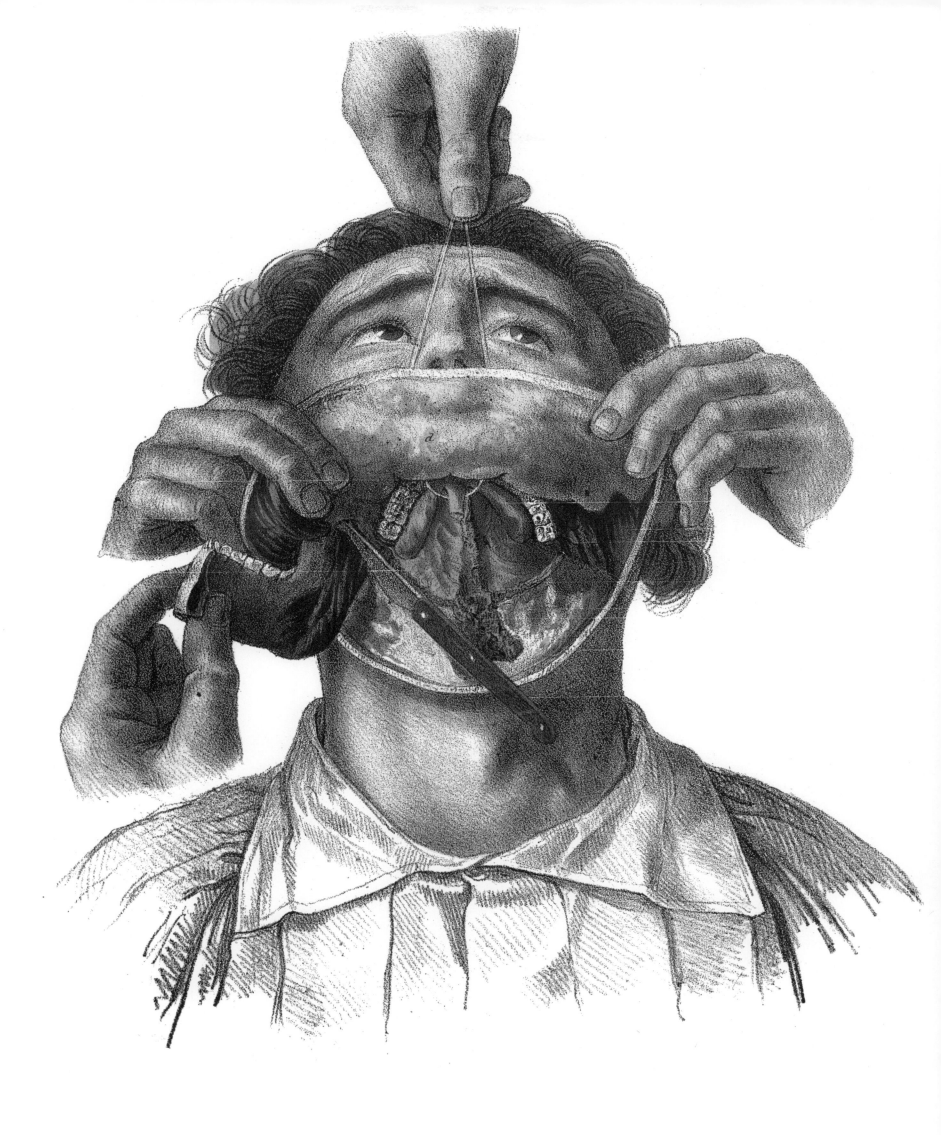

Resection of the lower jaw
Joseph Pancoast, *A treatise on operative surgery comprising a description
of the various processes of the art.* 1846.

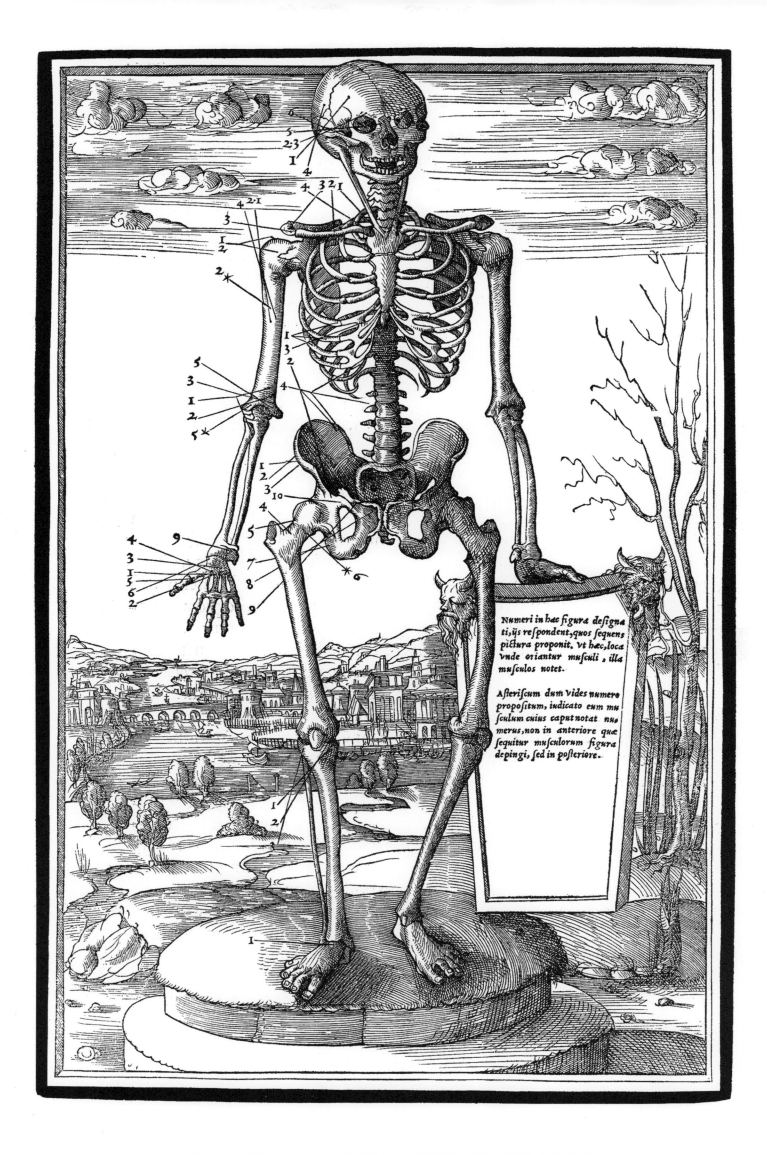

Numeri in hac figura designa
ti, ijs respondent, quos sequens
pictura proponit, vt hæc, loca
vnde oriantur musculi, illa
musculos notet.

Asteriscum dum vides numero
proposito, indicato eum mu
sculum cuius caput notat nu
merus, non in anteriore quæ
sequitur musculorum figura
depingi, sed in posteriore.

Human skeleton highlighting the bones of the right arm, hip and leg
Étienne de La Rivière, *De dissectione partium corporis humani.* 16th Century.

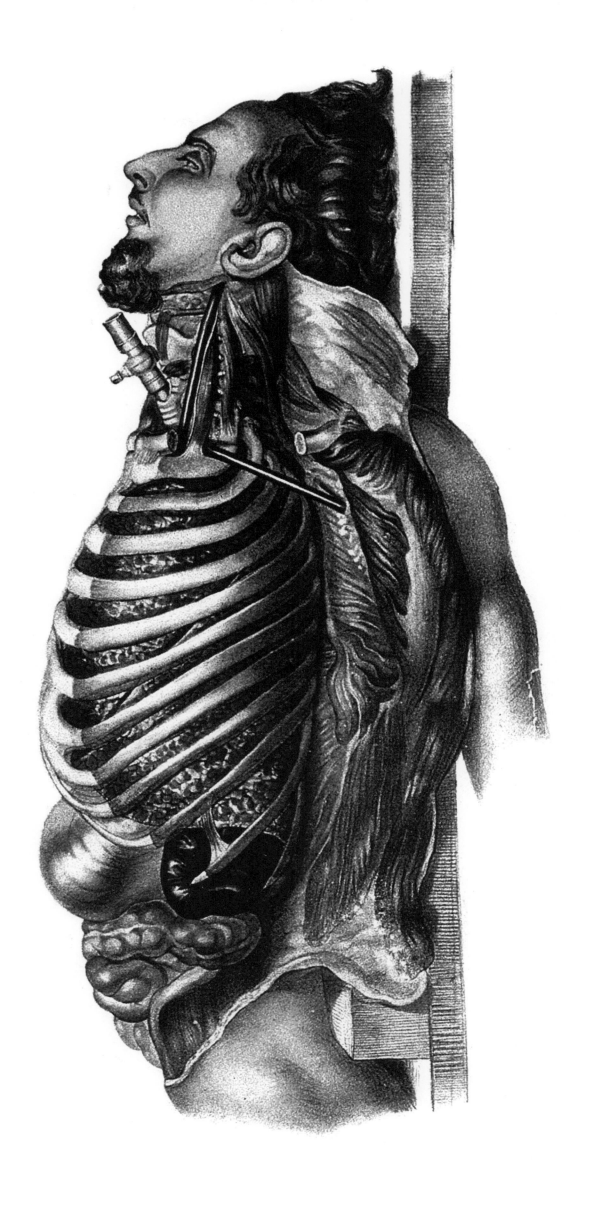

The body of a man lying down with the trunk dissected
William Fairland, *Iconographic, The body of a man lying down.* 1869.

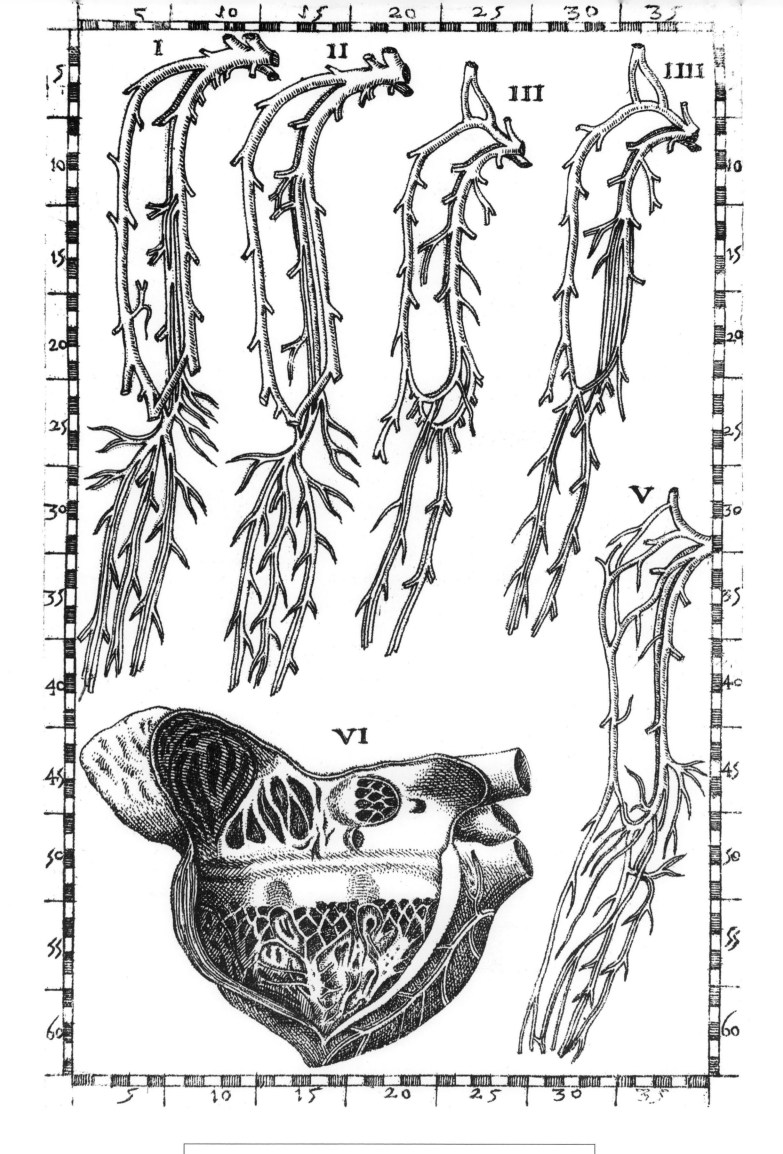

The external carotid artery, and its branches
Joseph Maclise, *The anatomy of the arteries of the human body : with its applications to pathology and operative surgery.* 1844.

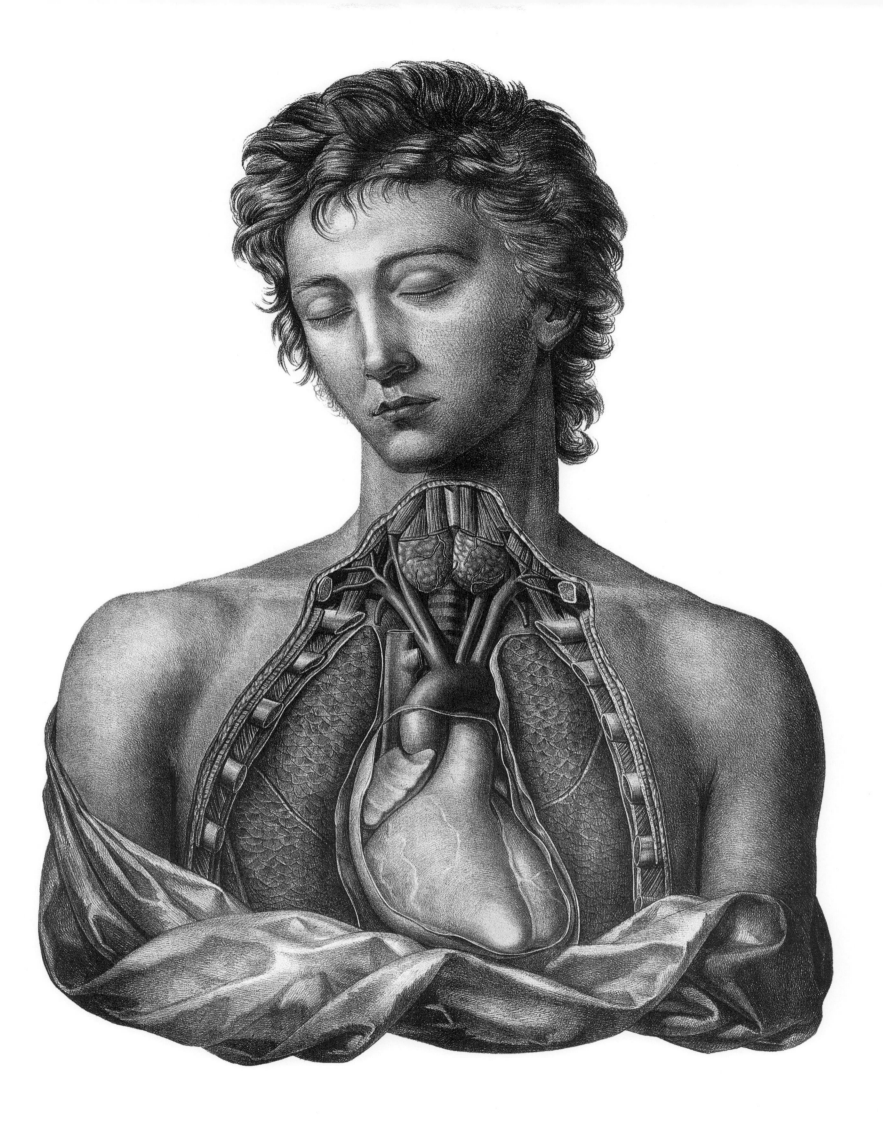

Dissection
Jakob Wilhelm Roux after Friedrich Tiedemann, *Tabulae arteriarum corporis humani*. 1822.

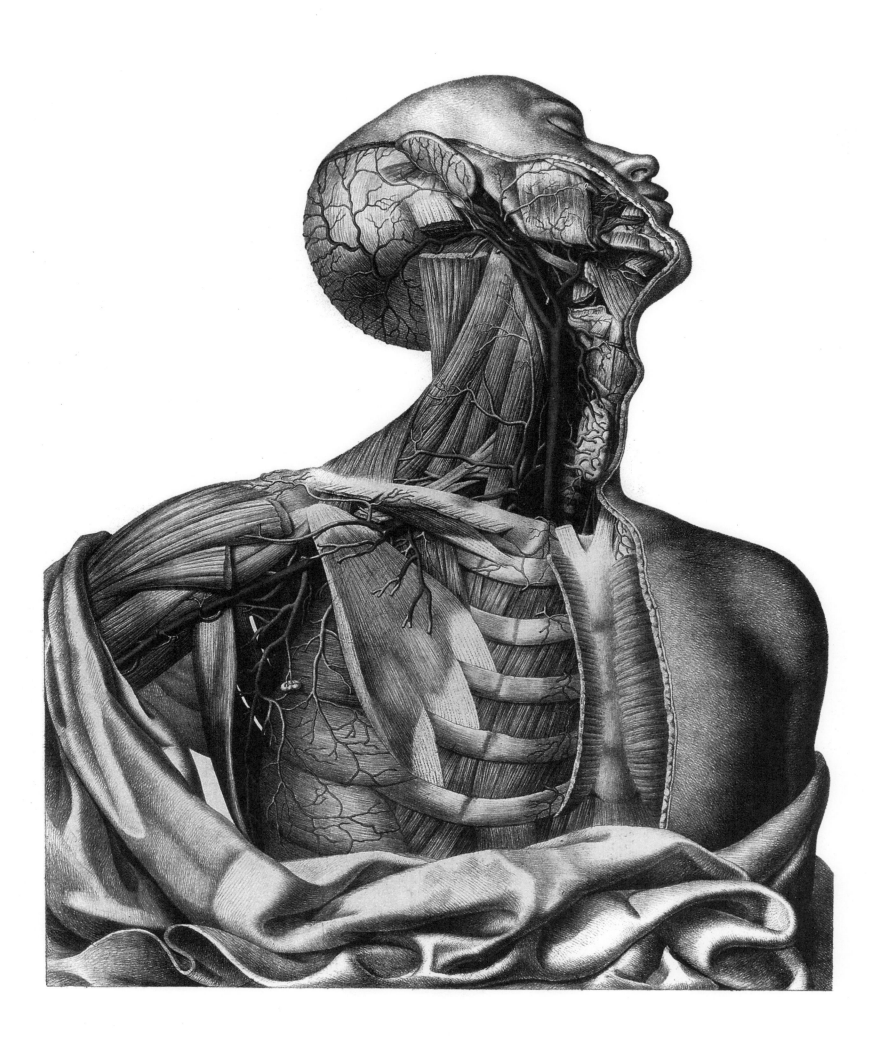

Dissection
Jakob Wilhelm Roux after Friedrich Tiedemann, *Tabulae arteriarum corporis humani.* 1822.

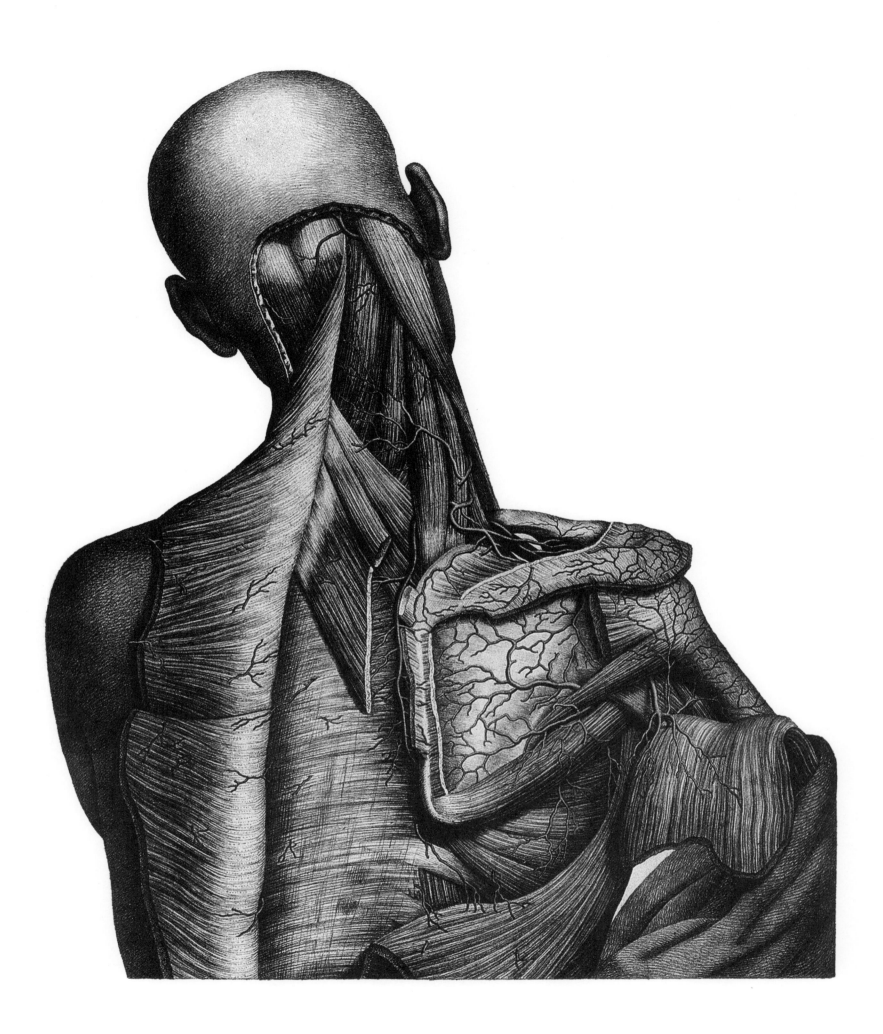

Back
Jakob Wilhelm Roux after Friedrich Tiedemann, *Tabulae arteriarum corporis humani*. 1822.

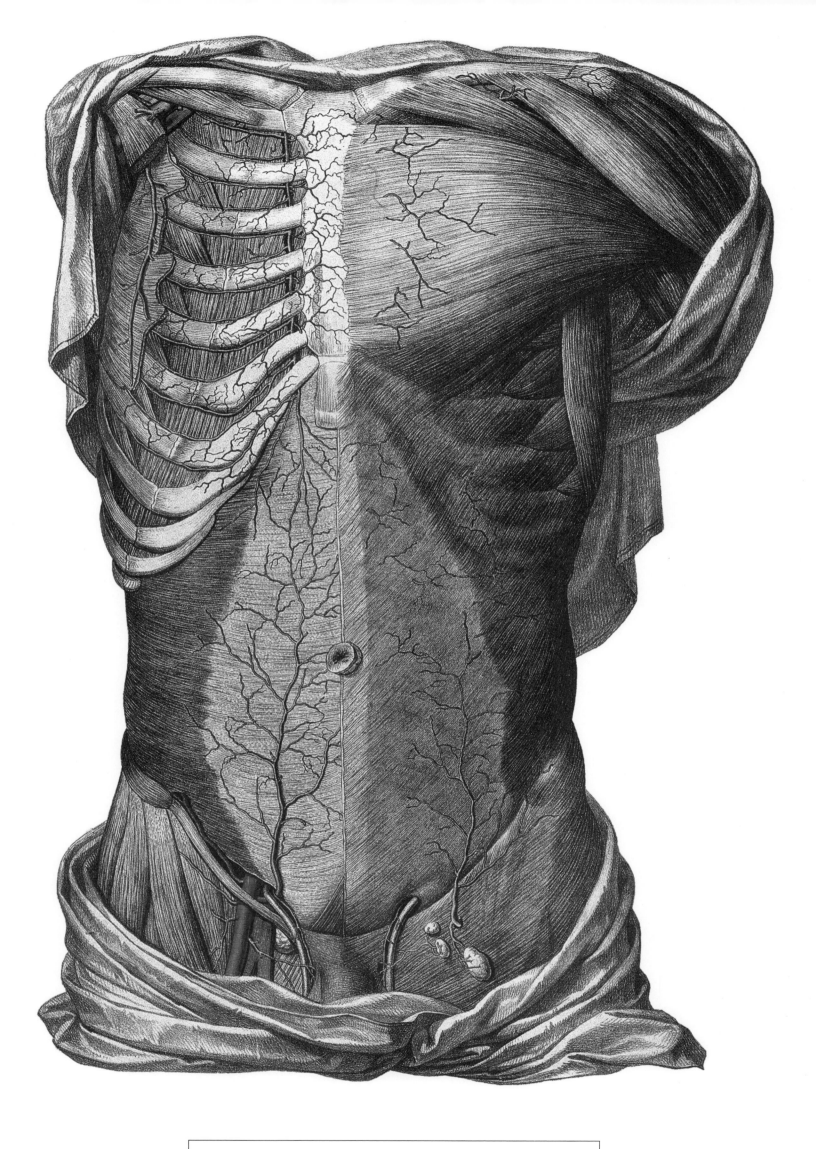

Dissection of the male torso, showing the muscles, bones and lymph nodes, with the arteries, blood vessels and veins
Friedrich Tiedemann, *Tabulae arteriarum corporis humani*. 1822.